D1590714

BEACON HILL
THROUGH TIME

ANTHONY M. SAMMARCO

PHOTOGRAPHS BY PETER B. KINGMAN

AMERICA
THROUGH TIME®
ADDING COLOR TO AMERICAN HISTORY

This book is dedicated to my cousin
William Hesseltine Pear II
Longtime Historian of the Nichols House Museum
and Boston Boulevardier

Opposite page: Seen in one of my favorite nineteenth-century prints of Boston, by John H. Bufford in 1858 after a drawing by John Rubens Smith, workers use picks and shovels to cut away at Beacon Hill, seen behind the Massachusetts State House, with Bulfinch's majestic eagle surmounted column rising from the remnants of Beacon Hill. Using both cows and horses with tip carts to help move the soil, it was to be cut down between 1811 and 1824 and the soil from Beacon Hill to be used to create the "Flat of Beacon Hill," the newly created land between Charles Street and the Charles River as well as to infill the Mill Pond in the North Cove (now the area of Causeway Street).

America Through Time is an imprint of Fonthill Media LLC
www.through-time.com
office@through-time.com

Published by Arcadia Publishing by arrangement with Fonthill Media LLC
For all general information, please contact Arcadia Publishing:
Telephone: 843-853-2070
Fax: 843-853-0044
E-mail: sales@arcadiapublishing.com
For customer service and orders:
Toll-Free 1-888-313-2665

www.arcadiapublishing.com

First published 2021

Copyright © Anthony M. Sammarco 2021

ISBN 978-1-68473-012-4

Typeset in Mrs Eaves XL Serif Narrow
Printed and bound in England

CONTENTS

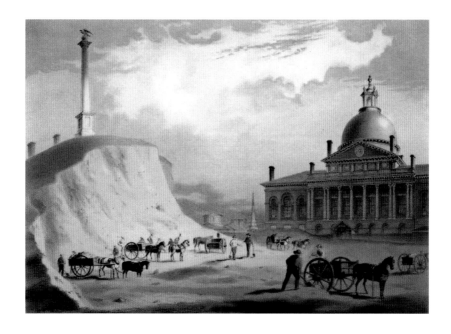

ACKNOWLEDGMENTS

I wish to especially thank Peter Bryant Kingman for his wonderful contemporary photographs of Beacon Hill. He has captured the essence of the vintage photographs and has made this book not just an interesting compilation of the houses, businesses, squares and streetscapes of this historic neighborhood of Boston, but a visually fascinating one as well.

We wish to extend our sincere thanks and deep appreciation to:

Robert Allison; Charlie Anderson; John A. Anderson; Joel Andreasen; the late Smoki Bacon and Richard Concannon; Hope Baker; Mitch Blaustein; the Boston Athenaeum, Amy Ryan; Boston Fire Department Archives; Boston Public Library, David Leonard; Boston Society of the New Jerusalem, Reverend Kevin Baxter; the Trustees of Boston University; Diana Roberts Bray; Hutchinson and Pasqualina Cedmarco; Cesidio Cedrone; Clayton Cheever; the late Frank Cheney; the Church of the Advent, The Reverend Douglas Anderson, Rector; City of Boston, ISD, Brigid Kenny-White; Edie Clifford; William Clift; the late Morton Cole; National Society of the Colonial Dames of America; Colortek, Jackie Anderson; Community Boating, Inc.; the late Rupert A.M. Davis; DeLuca's Market, Virgil Aiello; Digital Commonwealth; eBay; Mary Anne English; First Baptist Church of Boston, Reverend John R. Odoms; Edward Gordon; Joan Halpert and Peter Hanson; Charles Hammond; Helen Hannon; Bayard Henry; Joseph L. Hern; Historic New England, Lorna Condon; David Jacobs and Gen Tracy; George Kalchev, Fonthill Media; Carolyn Karp; Peter B. Kingman; the late Sally Kydd; John Labadini; Douglas Lee; Lauren Leja; Kena Longabaugh; John E. Lynes; Alex McVoy MacIntyre; Stephanie Machell; the late Mrs. Charles E. Manson; Michael Meehan; Mateusz Minsky; Keith Morgan; Eddie Mulkern; the late Robert Neiley, AIA; Nichols House Museum; Frank Norton; Orleans Camera; the Park Street Church, Rev. Mark L. Booker; The Paulist Center, Father Michael McGarry, CSP; Payne/Bouchier, Steve Payne, Oliver Bouchier and Lee Reid; Linda Pearl; the Persechini Family; Sally Pierce; the late Elva Sawyer Proctor; the late Roger Prouty; Becky Putnam; Rogerson Communities, Beacon House; Maria Pope Rowley; Jeff Rubin; the late Dexter and Charlotte Tuttle Clapp Sammarco; the late Sylvia Sandeen; Ron Scully; Robert Bayard Severy; the late Alice Warburton Shurcliff; Robert W. Stone; Alan Sutton, Fonthill Media; Archives and Special Collections, University of Massachusetts, Sammarco Collection; the late George Ursul; Vilna Shul, Barnet Kessel, Executive Director; the Vincent Club; the late Paul Weiner; West End Branch Library, Helen Bender.

Photographs are from the collection of the Boston Public Library unless otherwise credited.

INTRODUCTION

The Boston State-House is the hub of the solar system. You couldn't pry that out of a Boston man, if you had the tire of all creation straightened out for a crowbar.

<div align="right">Oliver Wendell Holmes</div>

Beacon Hill is a historic neighborhood of Boston which is closely identified with the Massachusetts State House, which was built on the South Slope in 1798. However, the name "Beacon Hill" does not just represent a metonym to refer to the state government or the legislature itself, but from the wood beacon that once surmounted the hill as the highest point in the town of Boston and from which a tar bucket—others say an iron skillet—was suspended that would be ignited to alert Bostonians that there was a calamity or invasion. Beacon Hill was one of the three hills of Boston referred to as the Trimount, later to be corrupted as Tremont and for which a street was named, that included Mount Vernon on the left of Beacon Hill and Pemberton Hill on the right. Known for its Federal and Greek Revival-style row houses, narrow gas lit cobblestone streets and brick sidewalks which adorn the neighborhood, it is not just a historic neighborhood but one that embraces people of all walks of life from the early nineteenth century to the present.

Beacon Hill is bounded by the Charles River and Cambridge, Tremont, Park and Beacon Streets. Beacon Hill has three areas that have two centuries of architecture known as the South Slope, the North Slope and the Flat of Beacon Hill, which is a series of streets between Charles Street and the Charles River that was infilled from the cutting down of Beacon Hill. Topographical changes began as early as 1795 with the construction of the State House, which was completed in 1798 and which rose behind the building to the height of the state house dome, and residential development subsequently followed. In the first three decades of the nineteenth century, Beacon Hill was to be cut down by hand from 138 feet in elevation to 80 feet, and the soil was taken by a railroad to the bottom of the hill and used to infill and create buildable land. The area at the western slope of Beacon Hill between Charles Street and the Charles River was infilled with soil carted to the foot of the hill by a gravity railway system to create not just new land but a series of streets that were laid out and stretched from Beacon Street opposite the Public Garden to Cambridge Street.

The development of Beacon Hill began when Charles Bulfinch, an architect and planner, was commissioned by the Mount Vernon Proprietors, who had acquired much of the land

from John Singleton Copley, to lay out the new neighborhood with streets connecting the hill with Charles Street and cross streets. Mount Vernon Street, named for one of the former hills, was laid from Bowdoin Street westward and was envisioned by Bulfinch to have large freestanding red brick mansions set on small lots of land, many of which were designed by Bulfinch for the proprietors. One of the first homes was that of Dr. John Joy who in 1791 commissioned Bulfinch to build his house on the hill. Another was Harrison Gray Otis, whose house was built in 1795 on Cambridge Street. These large neoclassical inspired mansions were to transform Beacon Hill into an elegant and planned neighborhood that attracted prominent and newly affluent Bostonians to build their houses in close proximity to the State House.

As Beacon Hill was developed in the early nineteenth century with impressive row houses of red brick and with tree lined squares and streets, designed by such architects as Charles Bulfinch, Asher Benjamin, Solomon Willard, Cornelius Coolidge and Alexander Parris, Bostonians were impressed with the character of the new neighborhood and chose it as their place of residence. It was to become home to bankers, financiers, merchants and attorneys, as well as educators, writers and members of the new transcendental movement that swept Boston in the 1840s. However, not everyone was enamored of the city and its municipal and topographical achievements. Edgar Allan Poe had published his first volume of poetry with the pseudonym "A Bostonian." Poe had come to mockingly dismiss Boston, ironically the town of his birth, as *Frogpondia*, and its resident authors and writers as chasing after elusive transcendental fads. Poe was a harsh and vocal critic and obviously thin skinned, but though Boston had become a city in 1822, it was still really a small town and he summarily dismissed the writers such as Henry Wadsworth Longfellow, considered the chief *Frogponder*, closely followed by Oliver Wendell Holmes, James Russell Lowell and John Greenleaf Whittier.

By the 1840s, Beacon Hill was being developed with houses along Beacon, Chestnut, Mount Vernon and Pinckney Streets that were red brick or later brownstone row houses that were owned by the Boston Brahmins, a Sanskrit word that was used to describe a class of Bostonians that were humorously described by Oliver Wendell Holmes as a "harmless, inoffensive, untitled aristocracy." The cachet of the early houses designed by Charles Bulfinch had a prominent presence on Beacon Street facing the Boston Common. Inside these houses were newly minted ancestral portraits and Chinese porcelains brought back from the lucrative China trade. Humanitarianism, benevolence, Unitarianism in the belief in the perfectibility of man, Yankee shrewdness, and an exclusiveness that was not just social but extended to education, trade, commerce and marriage, was alive here. By the time of the Civil War, Beacon Hill was largely built up and was an achievement that neither Bulfinch nor the Mount Vernon Proprietors could have envisioned seven decades earlier. However, some residents, beginning in the 1860s, would choose to move to the newly infilled Back Bay with its French-inspired boulevards and mansard-roofed houses that were larger, lighter and airier than those on the closely built streets of Beacon Hill.

The Flat of the Hill, the area from Charles Street west to the Charles River, was developed in the early part of the nineteenth century by the cutting down of Beacon Hill with houses built which often had small shops on the ground floor for retailers, carpenters and shoemakers, as well as carriage houses for the large houses on the hill itself. This newly created land had new streets laid out which attracted not just residential growth but ecclesiastical growth with

the Charles Street Meeting House and the Church of the Advent anchoring Mount Vernon Street between Charles and Brimmer Streets. The North Slope, which claims the oldest extant house on Beacon Hill, said to be on South Russell Street, had red brick row houses. The area in the early nineteenth century became a neighborhood of African Americans moving from Boston's North End as well as immigrants arriving in Boston.

The area around Joy Street, originally known as Belknap Street, had many African American families who were domestic workers in the homes of wealthy residents on the south slope of the hill; the community on the north slope was already well established by 1805, before the filling-in of the South Slope was completed, and before Beacon Hill came to be considered an affluent area. Many African Americans in the neighborhood attended Boston churches, but did not have a vote in church affairs and had segregated seating. As a result of this non-inclusion, the African Meeting House was built in 1806 on the North Slope and by 1840 there were five black churches in Boston. The African Meeting House on Smith Court off Joy Street was not only a place of worship, but a community center where Frederick Douglas spoke about abolition, and where William Lloyd Garrison formed the New England Anti-Slavery Society. The North Slope of Beacon Hill was to become a "hotbed and an important depot on the Underground Railroad in the years leading up to the Civil War."

In the late nineteenth century, the North Slope of Beacon Hill also saw tremendous numbers of immigrants moving there which included Irish, German, Lithuanian and Russian Jewish and other immigrants that lived alongside the earlier African American residents. Many houses built in the earlier nineteenth century were dilapidated by the 1880s and were razed for new housing. Brick tenements of four and five stories replaced the former three-story red brick or wood row houses. New buff brick apartments were constructed, generally with commercial shops with windows on the first floor and an impressive cornice, and many residential homes were converted to boarding houses. Not only did the new immigrants live on the North Slope, but they founded in 1898 Anshe Vilner, a Lithuanian *chevra* now known as Vilna Shul, on Phillips Street. In 1862, they purchased the Twelfth Congregational Church in the West End and dedicated it to St. Joseph as a Roman Catholic church. The North Slope demographics evolved as African Americans moved out of the neighborhood and immigrants, such as Eastern European Jews, made their homes there. In fact, the African Meeting House was converted into the Anshei Libawitz shul in 1890 and remained a Jewish place of worship until 1972.

Due to new development in the early twentieth century, and to ensure that there were controls on new development and demolition, the Beacon Hill Association was formed in 1922. West Hill Place and Charles River Square, two cul-de-sacs of Georgian Revival row houses facing the Charles River Esplanade, were built on the Flat of Beacon Hill. Upscale apartment buildings were built, drawing architectural details of the early nineteenth century so they conformed to the neighborhood. As families began to eschew five-story row houses for apartment flats on one floor, or the suburbs, Beacon Hill began to see dramatic changes that transformed the neighborhood with banks, restaurants and small shops along Charles and Cambridge Streets. With changes that seemed to imperil the charming enclaves of Beacon Hill, state legislation created the Historic Beacon Hill District in 1955. This was the first such historic district in Massachusetts and was created to protect historic sites and

manage urban renewal. Supporting these objectives is the local Beacon Hill Civic Association, and Beacon Hill was designated a National Historic Landmark in 1962. Today Beacon Hill is predominantly residential, known for its nineteenth-century brick row houses with "beautiful doors, decorative iron work, brick sidewalks, narrow streets, and gas lamps," but it is also a neighborhood with a rich and ever evolving history that literally embraces Boston history with not just Boston Brahmins, but African Americans and diverse immigrant groups, all of whom created what writer Oliver Wendell Holmes, in his 1858 article, "The Autocrat at the Breakfast Table" in the *Atlantic Monthly,* called Beacon Hill *The Hub of the Solar System.*

Boston Toast
"And this is good old Boston,
The home of the bean and the cod,
Where the Lowells talk only to Cabots,
And the Cabots talk only to God."

John Collins Bossidy

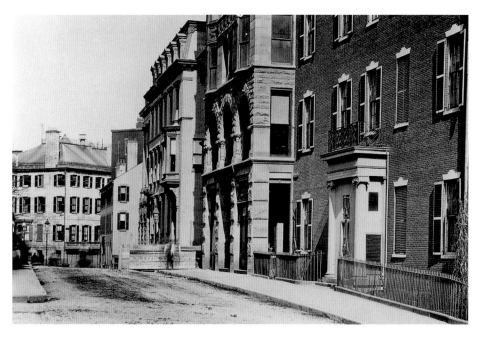

Beacon Street, looking east from Park Street on the right, was a panoply of architectural styles in this photograph. Named for the beacon that surmounted Beacon Hill, the street would eventually be laid across the marshes of the Back Bay and continue west through Brookline to the suburbs. On the right is the Amory-Ticknor House, the Congregational Library, the Boston Athenaeum and on the left the home of Benjamin W. Crowninshield, located at the corner of Beacon and Somerset Streets, later the first location of the Somerset Club.

1

FROGPONDIA

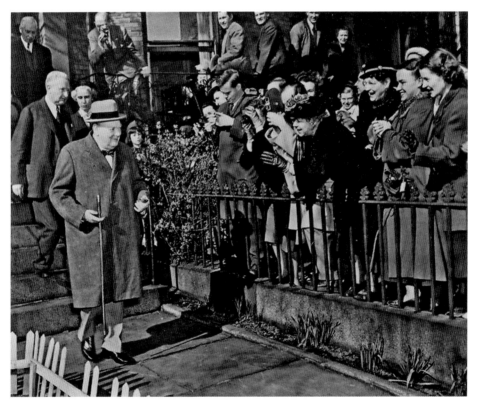

In March 1949, Winston Spencer Churchill was in Boston to deliver the keynote speech at the Massachusetts Institute of Technology Mid-Century Convocation, a three-day symposium on the "Social Implications of Scientific Progress" which was held at the Boston Garden. Churchill devoted much of his speech to relations between the West and the Soviet Union. Churchill is seen leaving the Club of Odd Volumes, a society of bibliophiles founded in 1887, at 77 Mount Vernon Street after a luncheon hosted by his publishers Houghton Mifflin, as affable camera toting Bostonians line the walkways of adjacent houses.

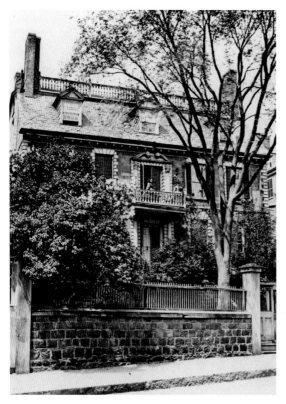

Designed by Joshua Blanchard and built in 1737 of hammered granite, Thomas and Lydia Henchman Hancock wanted a house that showed his newfound wealth as a leading merchant in Boston. The family built the house on Beacon Hill, named for the beacon that surmounted a tall pole on its ninety-foot summit, which was a distance from the town center. Inherited by John and Dorothy Quincy Hancock, they lived a sumptuous lifestyle, and they entertained lavishly while Hancock was president of the Provincial Congress and later as the first governor of the Commonwealth of Massachusetts. Standing on the balcony in 1863 are Elizabeth Lowell Hancock Moriarty Wood, on the left, and her friend Sarah Maria Cheney Train. The estate surmounted the crest of Beacon Hill with various outbuildings, formal and vegetable gardens, fruit orchards and pastures and was entered from a gate flanked by a stone wall with a fence surmounting it.

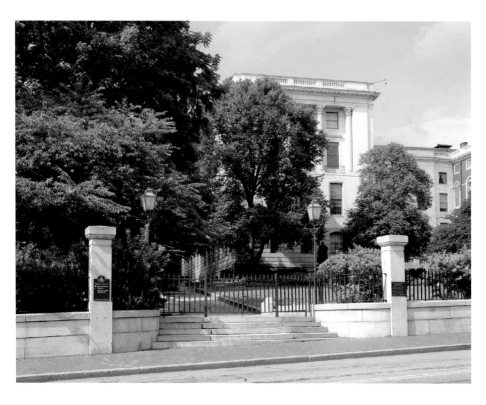

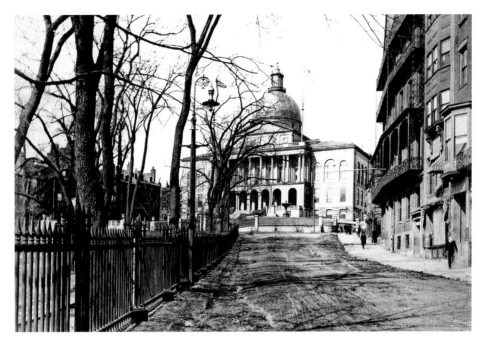

The Massachusetts State House, seen from Park Street, was designed by Charles Bulfinch and was completed in January 1798 at a cost of $133,333.33. Considered a masterpiece of Federal architecture and among Bulfinch's finest works, it was designated a National Historic Landmark for its architectural significance. The original wood dome was covered with copper in 1802 by Paul Revere's Revere Copper Company and was gilded with gold leaf in 1874.The dome is topped with a gilded, wooden pine cone, symbolizing both the importance of Boston's lumber industry during early colonial times and of the state of Maine, which was a part of Massachusetts until 1820. Oliver Wendell Holmes said in the "Autocrat" that the "Boston State House is the hub of the solar system." On the right is the Union Club of Boston. [*Author's Collection*]

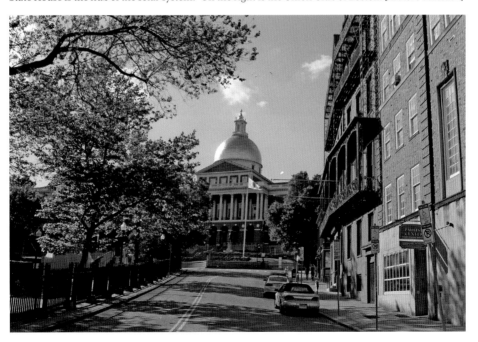

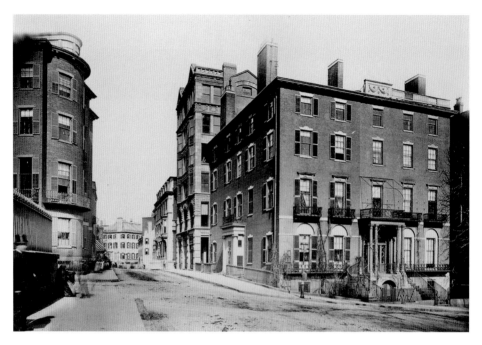

The Amory-Ticknor House was designed by Charles Bulfinch and built in 1804 at the corner of Beacon and Park Streets. Known as "Amory's Folly," it was the largest house in Boston at that time, but due to bankruptcy, it was divided into a duplex and George Ticknor lived in one half. By the late 1880s it was drastically altered with two-story metal orioles and became the Ticknor Building with offices for numerous businesses on all floors. Just to the left is the Claflin Building designed by William Gibbons Preston and built in 1884. On the right were the homes of John Amory Lowell and Abbott Lawrence which were joined as the Union Club of Boston in 1863. The row house on the far left was demolished in 1916 for the expansion of the State House.

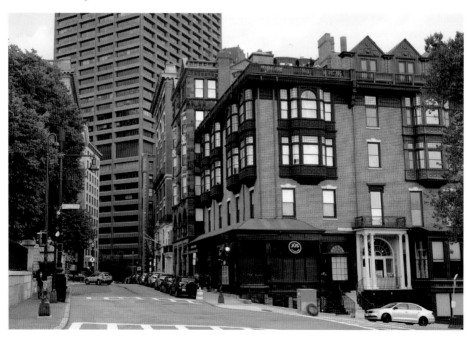

The three houses at 13, 15 & 17 Chestnut Street were designed by Charles Bulfinch and built in 1806 for Hepzibah Clarke Swan, one of the five original members of the Mount Vernon proprietors whose goal was to transform Beacon Hill into a fashionable neighborhood. The three adjoining houses were built as wedding gifts for her three daughters. The houses are regarded as among the most architecturally significant on Chestnut Street with recessed ground-floor brick arches and elliptical iron balconies. The house at 13 was occupied by Swan's daughter, Mrs. John Turner Sargent. From 1863 to 1866, the house was rented to the humanitarian and abolitionist couple, Samuel Gridley Howe and his wife, Julia Ward Howe, author of *The Battle Hymn of the Republic*. Starting in 1867, Julia Ward Howe held meetings of the Radical Club in the house.

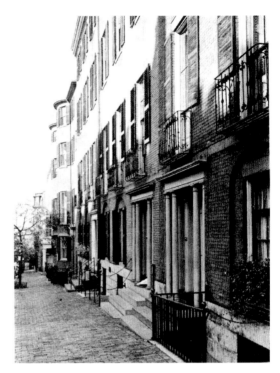

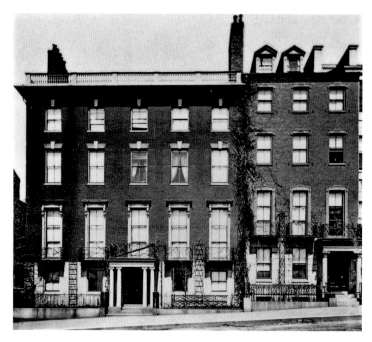

The Third Harrison Gray Otis House was designed by Charles Bulfinch and built in 1806 at 45 Beacon Street for Boston's third mayor. Otis' greatest legacy in Boston has probably been his three houses on Beacon Hill, all of which are still standing today as some of the finest examples of residential Federal architecture in the country. Otis resided in this house until his death in 1848. After Otis's death there were three owners of the house, including the Boy Scouts of America, until the American Meteorological Society purchased and renovated it in 1958. When built, the house was freestanding, with gardens on the right, a drive on the left and facing the Boston Common.

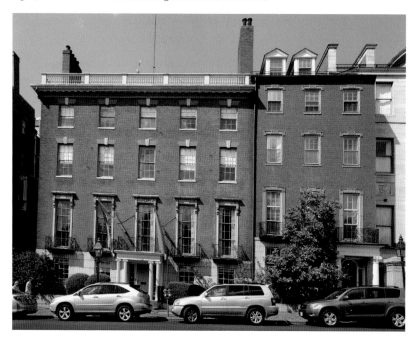

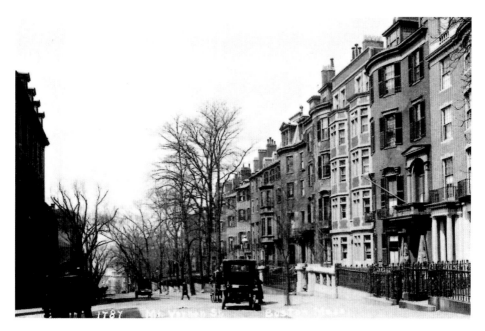

Henry James called Mount Vernon Street "the most proper street in Boston, and it rises straight as an ascendant arrow in eastward flight from Storrow Drive and the river embankment." On the left, at the corner of Walnut Street, is the duplex at 40-42 Mount Vernon Street designed by George Minot Dexter for William Ellery Channing Eustis and Augustus Hemenway with a rusticated base with ashlar blocks and two entrances of classical Greek Revival designs. On the right is the Tudoresque five-story apartment building at 65 Mount Vernon Street known as *The Cabot,* with the boldly engraved CABOT above the entrance indicating where the Cabots and Lodges once lived.

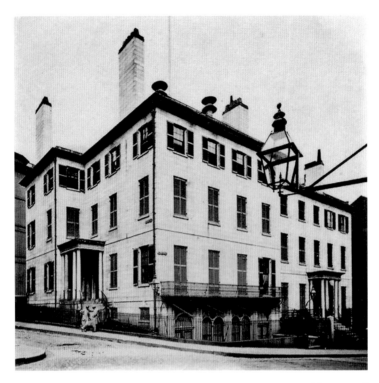

The two granite mansions which formerly stood at the corner of Beacon and Somerset Streets were owned by David Hinckley and John Lowell Gardner. In 1852, the houses became the home of the newly formed Somerset Club, and were used as the clubhouse for twenty years, until the club acquired by purchase the mansion house of David Sears on Beacon Street. In 1874, the Congregational House, a large granite building, was constructed with stores on the first floor and the upper part for society purposes. In 1898, the library was moved to 14 Beacon Street, an eight-story brick building designed by Shepley, Rutan and Coolidge with impressive bas-relief carvings by Domingo Mora.

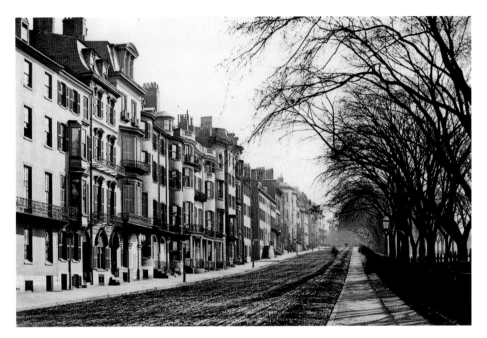

Beacon Street, looking toward the Massachusetts State House, was once known as "Poor House Lane" as the Almshouse was at the corner of Park Street. In 1708, Beacon Street, named for the beacon surmounting the hill, was laid out and the Hancock House was one of the few houses located here in the eighteenth century. Looking toward the State House in the 1860s, the panoply of houses include Federal Greek Revival and early Victorian row houses that face onto the Boston Common. The residents of Beacon Hill, called the Boston Brahmins, were described by Oliver Wendell Holmes as a "harmless, inoffensive, untitled aristocracy" living in "houses by Charles Bulfinch, their monopoly on Beacon Street, their ancestral portraits and Chinese porcelains, humanitarianism, Unitarian faith in the march of the mind, Yankee shrewdness, and New England exclusiveness."

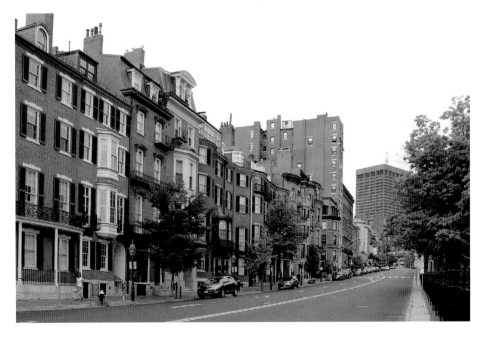

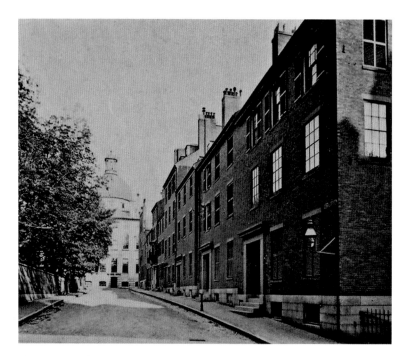

Mount Vernon Place, laid out in 1823 as Hancock Place, was adjacent to the State House off Joy Street. Built in 1833 by George W. Lyman, the house on the right is a three-story brick row house, sharing the flat facades and traditional brownstone elements of the others, which were built under the shadow of Boston State House. Mount Vernon Place cut through the former property of John Hancock. This street skirted the State House grounds to Mount Vernon Street on the summit of Beacon Hill. John Hancock's house was demolished in 1863 and that land used to make way for the State House addition.

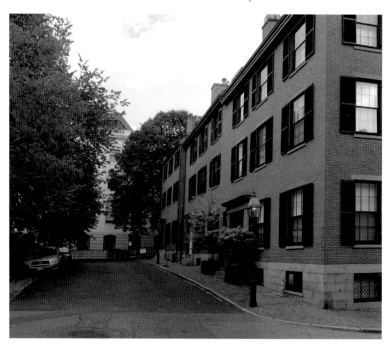

29A Chestnut Street was designed by Charles Bulfinch and built in 1800 as a side facing house with an Ionic columned entrance. At the request of the Mount Vernon Proprietors, Charles Bulfinch set out a pattern streets, designed mansions, and created an elegant urbane setting. This house was one of the first built. The house retains its side garden and the distinctive purple windowpanes with a street front bow added around 1818 by owner Charles R. Codman. 29A was once the residence of actor Edwin Booth, brother of infamous President Abraham Lincoln assassin John Wilkes Booth, and later was used by Hopkinson's Classical School for Boys.

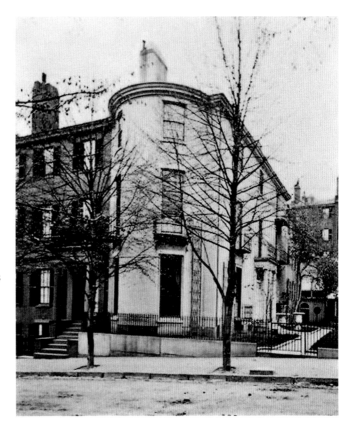

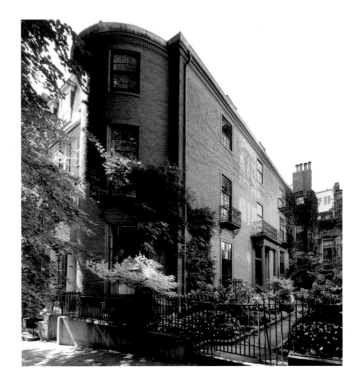

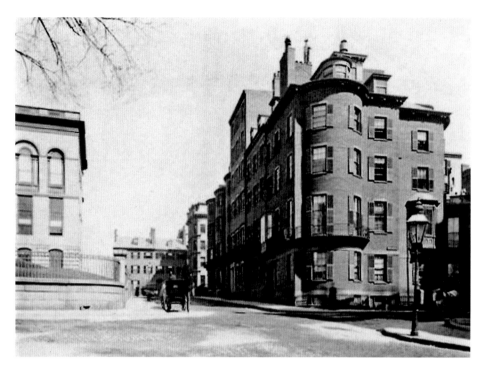

Mount Vernon Street once extended to Beacon Street opposite Park Street, seen in the foreground with a gas streetlamp. This four-story red brick row house from the 1840s was the home of the Williams Family and it commanded the corner. On the left can be seen the Massachusetts State House, which would have white granite wings designed by Sturgis, Bryant, Chapman & Andrews added to either side in 1917. The row house and those behind it were demolished to make way for the side driveway and lawn.

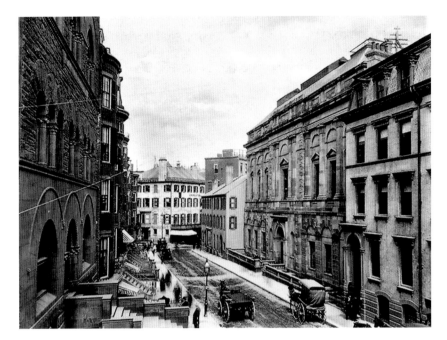

Beacon Street, seen in 1888 looking east from Bowdoin Street, had from the left the American Unitarian Association Building, in the center the Congregational Society Building and on the right the Boston Athenaeum. Remnants of the residential neighborhood are evident, but the large institutional buildings began to eclipse the early nineteenth-century streetscape.

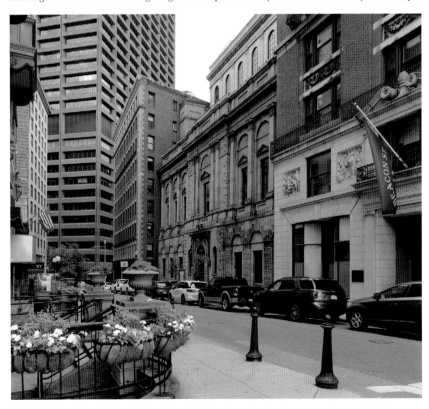

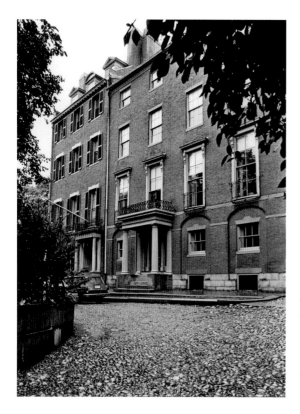

In 1805, Charles Bulfinch began building twin houses on the adjoining lots at nos. 87-89 Mount Vernon Street in Boston, which he had purchased from Harrison Gray Otis. There is an unverified story that he had intended one to be his own home, but facing financial difficulties, he sold 87 to Stephen Higginson, Jr., the father of Thomas Wentworth Higginson, and 89 to David Humphreys. The two buildings were set back from the street in order to line up with the adjacent Second Harrison Gray Otis House, also designed by Bulfinch. The house on the left was a new building, which was later remodeled in the Colonial Revival style. The house on the right was, for a time, the residence of Civil War General Charles Paine and since 1955, it has been the home of the Colonial Society of Massachusetts. [*Author's Collection*]

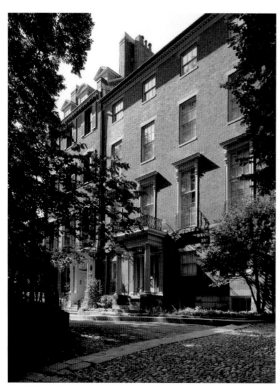

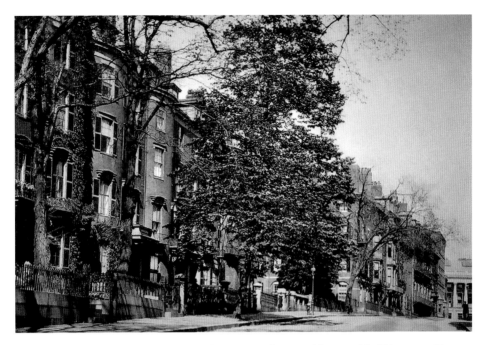

Mount Vernon Street, originally known as Olive Street and renamed for one of the Trimounts of Boston, was developed between 1800 and 1850, and although a few free-standing mansions were built, most of the homes constructed during this period were adjoining brick row houses, with either flat or bow fronts, built in the Federal style popularized by Bulfinch, or Greek Revival Style homes. In the early 1830s, a building boom began on Beacon Hill and many of the houses on the north side of Mount Vernon Street, between Louisburg Square and Walnut Street, were built on the site of the old Mason House; 63, 65 and 67 Mount Vernon Street were designed by George Minot Dexter. This row is between 83 and 55 Mount Vernon Street looking towards the State House. [*Author's Collection*]

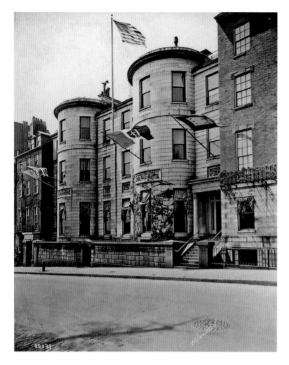

Originally known as the Beacon Club, it was renamed the Somerset Club in 1852 as the club was then located at the corner of Beacon and Somerset Streets. In 1871 the Somerset Club purchased the David Sears granite townhouse at 42 Beacon Street on Beacon Hill. Originally designed by Alexander Parris, with carved bas relief marble panels by Solomon Willard and built in 1819, Sears had enlarged the house in 1832, and later the club added the third floor, designed by Snell and Gregerson.

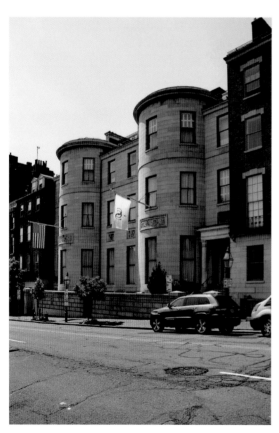

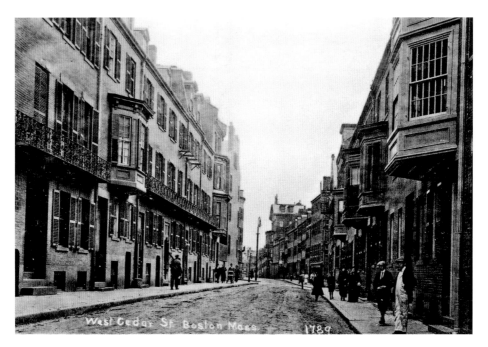

West Cedar Street was originally called George Street and was laid out in 1810 from Chestnut Street to Cambridge Street. Interestingly the early street names such as Olive (now Mount Vernon,) Chestnut, Spruce, Walnut and Cedar were all named for trees. Three-story red brick row houses, with stone lintels and many with wood orioles, were built creating an impressive streetscape. The row houses on the left had handsome cast iron railings along the *piano nobile*. Asher Benjamin built his own house at 9 West Cedar Street. [*Author's Collection*]

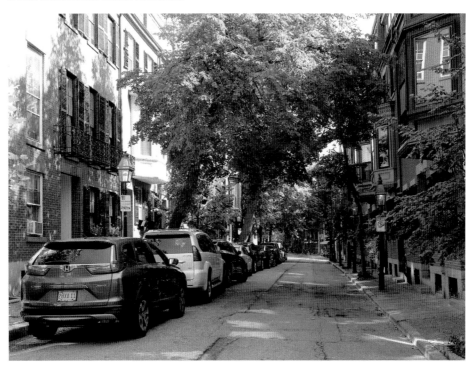

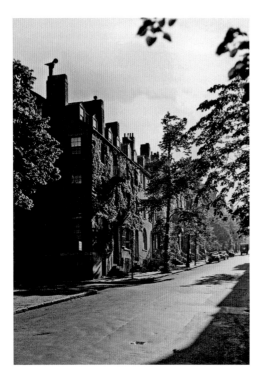

Chestnut Street, looking from the corner of West Cedar Street in 1950, had three-story row houses that blended both nineteenth-century architectural details with elegant embellishments such as demilune windows and sidelights at the front door, arched windows and others that created an attractive neighborhood. Cornelius Coolidge designed the row houses from 48 to 60 Chestnut Street. [*Author's Collection*]

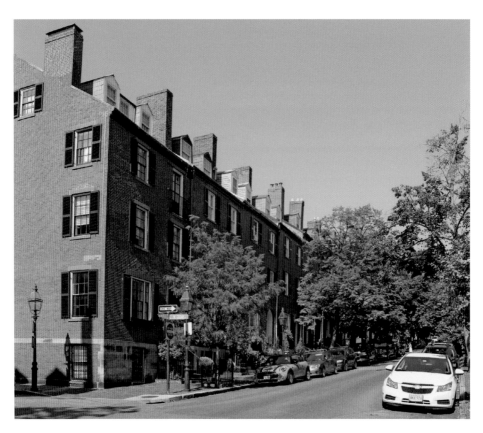

On the left, 8 Walnut Street is the home of Dr. George Parkman, a man more noted for his murder in 1849 by Dr. John Webster than for his medical skills, and on the right is 6 Walnut Street that became the Niser (National Institute of Science Education & Research) Hostel in 1945—a relocation hostel for Americans of Japanese descent. In 1942, President Franklin Delano Roosevelt had signed Executive Order 9066 with the intention of preventing espionage on American shores, and those people were transferred to facilities where they remained for the duration of the war. This hostel offered a place where Japanese Americans were able to begin to rebuild their lives after the war. [*Author's Collection*]

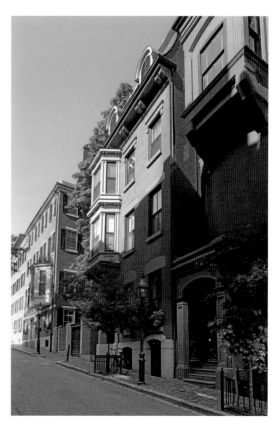

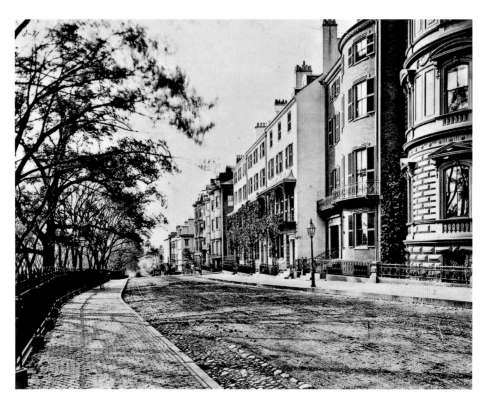

Beacon Street, just west of the State House, had the duplex Beebe-Brewer Mansion, which was designed by Gridley James Fox Bryant as the homes of James M. Beebe at 30 Beacon Street and Gardner Brewer at 29 Beacon Street, seen on the far right. The duplex houses were built on the site of the John Hancock House, which was demolished in 1863. These impressive houses were demolished in 1917 for the expansion of the Massachusetts State House. The uniformity of the streetscape along Beacon Street would be disrupted when *The Tudor*, a luxury French flat apartment building, was built in 1887 at the corner of Joy Street.

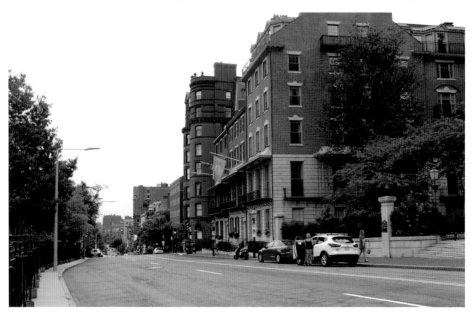

47-48 Beacon was designed by Richard Morris Hunt and built in the 1870 as a duplex for Martin Brimmer, a noted politician and first president of the Museum of Fine Arts Boston. Hunt had attended the Ecole des Beaux-Arts and remained in Paris until 1855 when he returned to the United States and became a leading society architect, and was considered "American architecture's first, and in many ways its greatest statesman." The duplex houses were red brick and limestone and had projecting two-story bay windows carrying up to the Mansard roof with fanciful dormers with an additional two stories. Full-blown Beaux Arts in style, the houses were to be demolished for the new townhouse of Eben Dyer Jordan, co-founder of the Jordan Marsh Department store, and a high-rise apartment house.

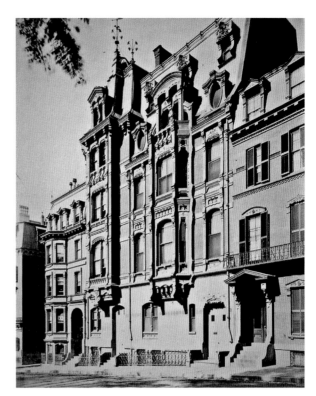

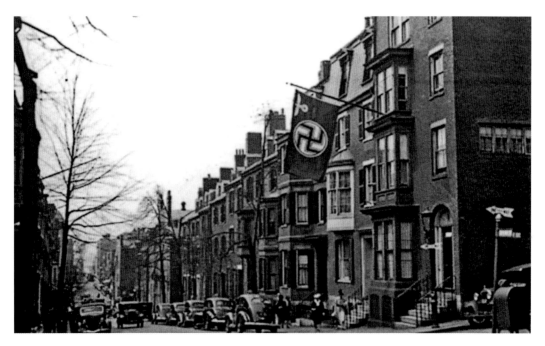

The German Consulate in Boston was located at 39 Chestnut Street, at the corner of Willow Street, on Beacon Hill. This was the office and home of the consul from Germany and the large flag of Germany was prominently hung from the residence in 1940 in observance of the fifty-first birthday of Adolph Hitler. Dr. Herbert Scholz, and his wife, Liselotte von Schnitzler Scholz, had served as the Secretary to the German Ambassador Herr Hans Luther from 1936 to1939 in Washington, D.C., and he was appointed German Consul in Boston in 1939. Frances Sweeney, publisher of the *Boston City Reporter*, called Boston the most anti-Semitic city in the country in the early 1940s, largely due to the Scholzes, who were considered enemy spies. Scholz created an espionage network until deported to Germany from the United States, where he was promoted to SS-Oberführer.

2

PEMBERTON AND LOUISBURG SQUARES

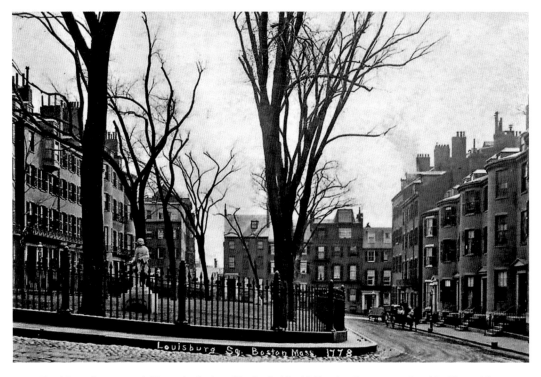

Louisburg Sq. Boston Mass. 1778

Louisburg Square was laid out similarly to Charles Bulfinch's Tontine Crescent on Franklin Place with a tree lined park enclosed by a cast iron fence that emulated the enclosed urban gardens of London. The red brick row houses were built between 1833 and 1847 and had swell bay facades on the right and flat facades on the left. The statue is of Christopher Columbus, a white marble mid-nineteenth century Italian carving that was a gift of the Marquis Niccolo Reggio, an Italian businessman and consul in Boston for the Papal States, Spain, and the kingdoms of Sardinia and of the Two Sicilies who lived at 3 Louisburg Square.

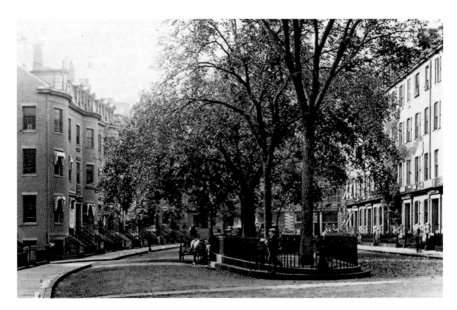

Pemberton Square was a gracious residential development that was laid out in 1835 on the site of the former home of Gardiner Greene and his terraced gardens on Pemberton Hill, one of the three hills of the Trimount of Boston. The square was described "dwellings built in it were fine, indeed elegant for their time, and for many years it was the residence of some of the most substantial citizens." George Minot Dexter designed the houses for Pemberton Square as well as the cast iron fences for the front yards and the fence with lamp posts for the central garden so that the buildings and fences would be similar in style and ornamentation. The eastern side of the square had three-story red brick swell bay facade row houses while the west side had four-story flat fronted facades. However, in the center of the square was an elliptical garden enclosed with a fashionable cast-iron fence with shade trees.

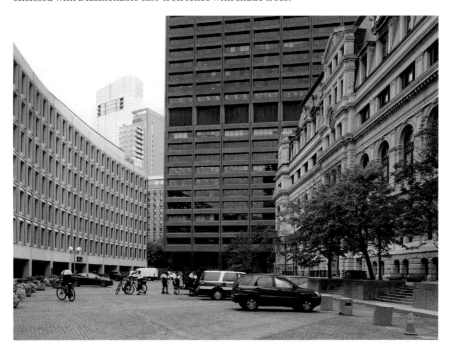

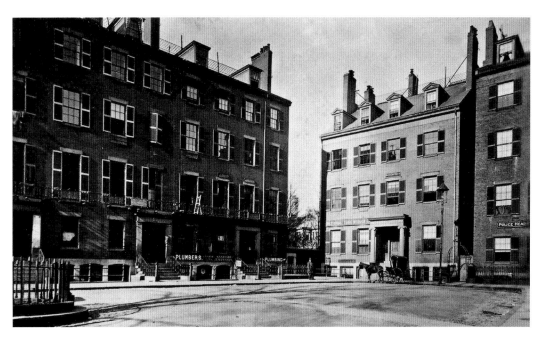

By the time of the Civil War, Pemberton Square had begun to change, and though there were many of the old families that remained in their houses, the area began to attract architects, lawyers and other professional men who were among the first to establish their offices in the once elegant mansions. Prominent architects such as Edward Clarke Cabot, Gridley J. Fox Bryant and Louis P. Rogers opened their architectural offices here. Also here was Boston University's Sleeper Hall, the Boston Conservatory of Elocution, Oratory and Dramatic Arts (now Emerson) as well as the offices of both Forest Hills Cemetery and Mount Auburn Cemetery. Shortly, the headquarters of the board of police commissioners, the Massachusetts Society for the Prevention of Cruelty to Children, as well as the Boston School for Deaf Mutes were located here and by 1875 the once fashionable square had fully given way to commerce as well as offices and schools.

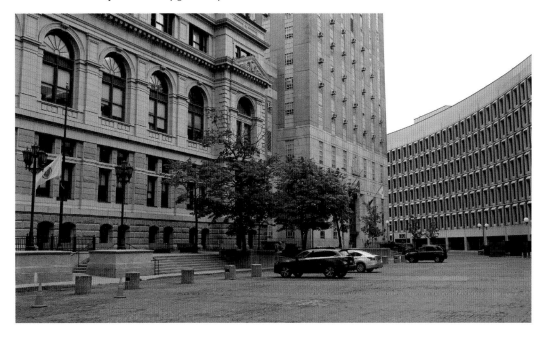

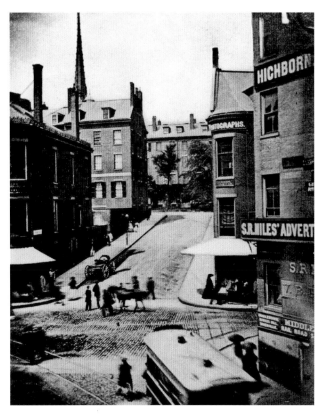

The street in the center leads from Scollay Square to Pemberton Square and shows the bustling commercial activity in the late 1880s. The building on the far right is the Scollay Building, and the photograph studio of Southworth & Hawes, a partnership of Albert Sands Southworth and Josiah Johnson Hawes, early photographers whose work elevated photographic portraits to the level of fine art, at the corner of Tremont Row. Rising above the rooftops on the upper left is the spire of the First Baptist Church on Somerset Street. Notice the streetcar in the foreground with the sign of the Middlesex Rail Road for streetcars destined for Charlestown and Somerville. [*Courtesy of Lauren Leja*]

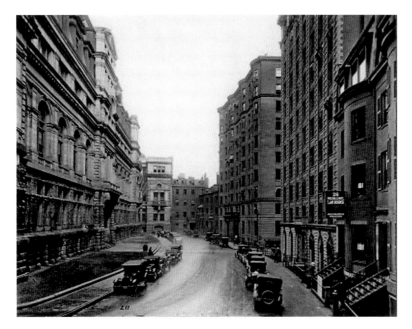

In 1885, Pemberton Square was selected as the site for a new courthouse, the building of which had been agitated for years. The row houses on the west side were razed in 1885 to make way for the Suffolk County Courthouse and the center garden was also removed. George A. Clough designed the massive Suffolk County Courthouse, also known as the John Adams Courthouse, which was built in 1893 on Pemberton Square, which also houses the Massachusetts Supreme Judicial Court and the Massachusetts Appeals Court. On the right is Barristers Hall, on the left is the Pemberton Building. Remnants of the east side of Pemberton Square survived until urban renewal took it in the early 1960s when it was replaced by the Government Center Plaza.

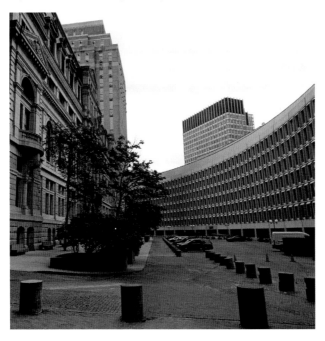

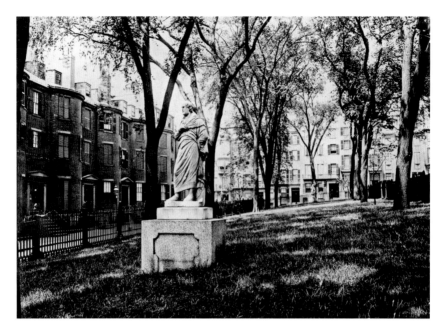

Louisburg Square was laid out as one of two parks on Beacon Hill with swell bay facade red brick row houses built facing the square. The houses were built between 1833 and 1847 and the statue of Aristides the Just, seen here, was erected in 1850 and was the gift of the Marquis Niccolo Reggio, an Italian businessman and consul in Boston for the Papal States, Spain, and the kingdoms of Sardinia and of the Two Sicilies. Although Louisburg Square can boast no Bulfinch designed houses, and is much more modern than some other sections of Beacon Hill, its retiring charm and English flavor make it one of the most attractive features of the neighborhood. In the early twentieth century, Louisburg Square was to become the location of an annual tradition of music, handbell ringing and caroling on Christmas Eve. [*Author's Collection*]

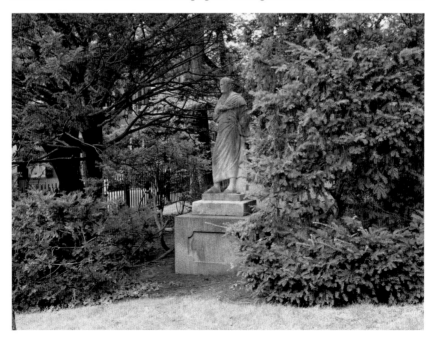

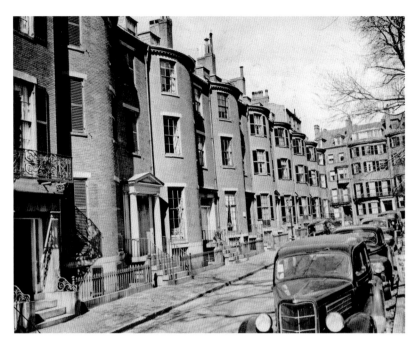

The red brick swell bay facade Greek Revival houses around Louisburg Square, a park owned by the twenty-eight lot owners who signed the Proprietors Indenture and Articles of Agreement and which ensured current and subsequent homeowners would act as stewards of the shared land, is one of the icons of Boston. The Proprietors of Louisburg Square is considered the earliest example of a homeowner association in America. Three stories in height, these row houses share a similarity of setback and red brick and create an urbane streetscape in what the Boston Globe called "a metaphor of permanence." [*Author's Collection*]

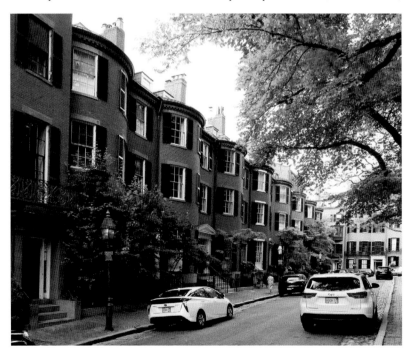

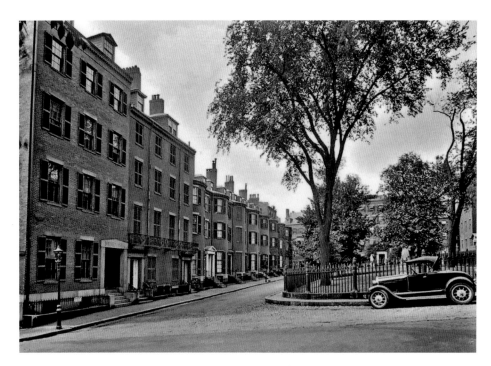

St. Margaret's Infirmary, later known as Birney Hall, was at the corner of Louisburg Square and Mount Vernon Street and was the dormitory for the Boston University School of Theology. Named for Lauress John Birney, it was opposite Warren Hall at 72-74 Mount Vernon Street, the former duplex townhouse of John and Nathaniel Thayer of John E. Thayer & Brother, which was reorganized as Kidder, Peabody & Company. Birney served as Dean of the School of Theology for nine years, where he also served as a trustee. While serving in that position, he was consecrated as a Bishop in 1920, later serving in Shanghai, China.

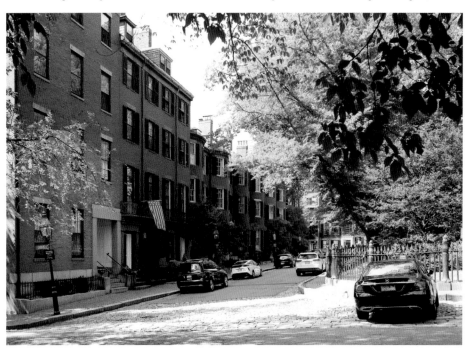

3

THE FLAT OF THE HILL

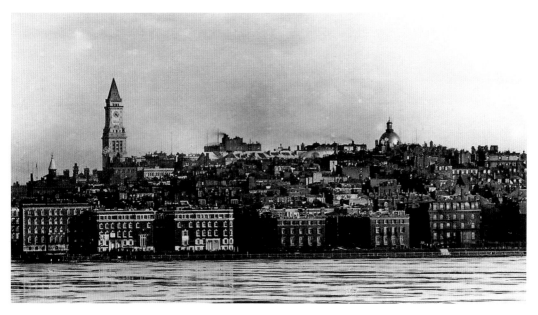

Looking from the Charles River, the area of the Flat of the Hill is seen in the early 1920s photograph. The elegant Massachusetts General Hospital Nurses' Residence (now the equally elegant Whitney Hotel) is seen on the far left and was built in 1909 for "nurses and domestic servants" at the hospital. Charles River Square and West Hill Place and are two charming European-like *cul-de-sacs* with red brick Georgian townhouses built in 1916 and 1917 respectively. The Boston skyline was punctuated by the Boston Customs House, Boston's tallest building until the Prudential Tower was built in 1964, and the gilded dome of the State House. [*Author's Collection*]

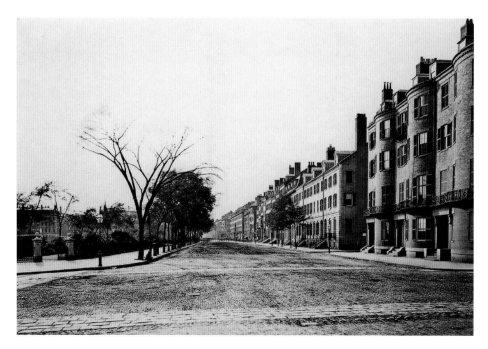

Originally known as the Mill Dam, a mile-and-a-half long and fifty-foot-wide stone dam, it was built in 1821 to dam the Charles River and enclose the Back Bay basin to utilize the flowing tidal waters for industrial production; it also would connect Beacon Hill with Sewell's Point (now Kenmore Square) as a toll road. Beacon Street, looking west from Charles Street, had in the 1840s three red brick four-story row houses at 67-68-69 Beacon Street designed by George Minot Dexter, later the Beacon Street Apartment Trust built on the site in 1917, and further along past River Street a row of granite houses from 70 through 75 Beacon Street, opposite the Boston Public Garden, which were designed by Asher Benjamin and built in 1828 by the Mount Vernon Proprietors on a speculative basis.

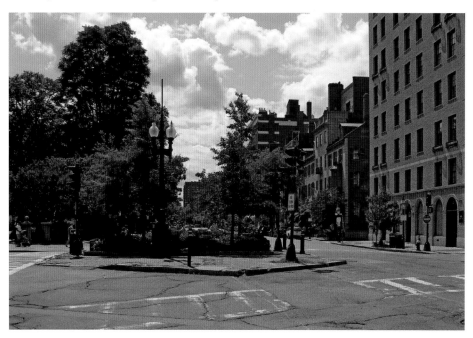

Chestnut Street, looking towards the State House from Brimmer Street, has a panoply of nineteenth- and twentieth-century architecture. On the left is the Church of the Advent and the Charles Street Meetinghouse, a spectrum of nineteenth-century ecclesiastical architecture from classical to high Victorian. The Art Deco addition to the Suffolk County Courthouse on Pemberton Square, designed by Cram and Ferguson Architects and built in 1937, rises high above the rooftops of Beacon Hill in the distance. Notice the traffic signal in the center of the street.

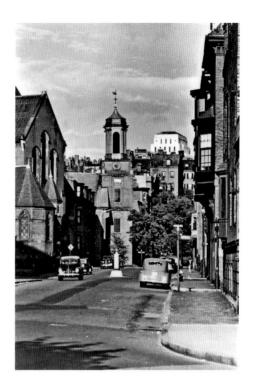

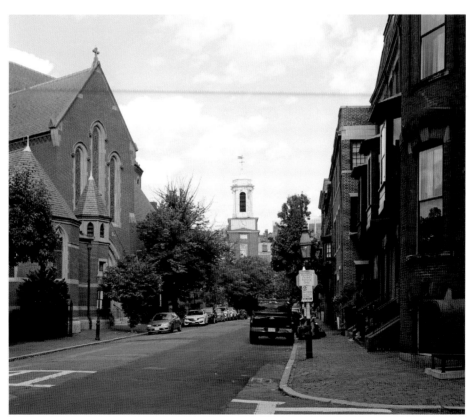

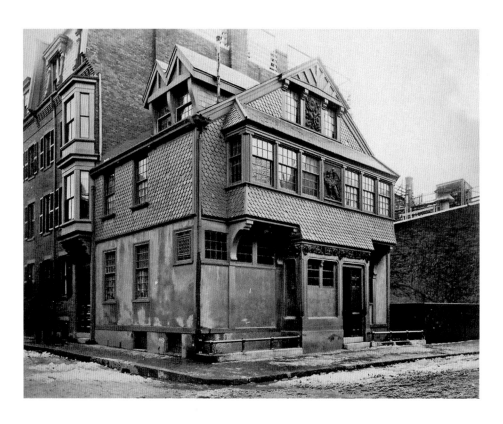

The Smith-Bourne House and Studio is at 130 Mount Vernon Street and is known as the "Sunflower House." Built in 1840, it was elaborately remodeled in 1878 by Charles Luce with the ground floor of stucco painted bright yellow, while the second floor and roof are covered with red shingles in an English fish-scale pattern. Two inset panels are of a black iron griffin and yellow sunflowers in the dormer. Gertrude Beals Bourne, a watercolor artist, moved into the house in 1904 with her husband, architect Frank Bourne, who created a studio on the third floor. Gertrude Bourne was a dedicated gardener and one of the founders and first president of the Beacon Hill Garden Club.

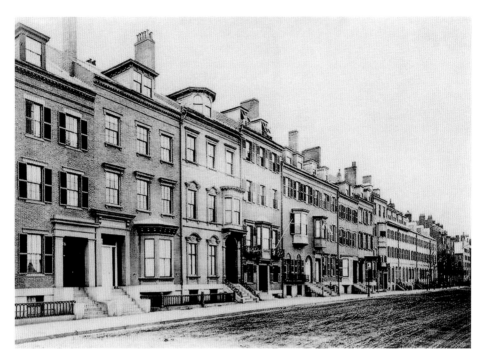

Beacon Street by the 1860s had a streetscape that was not architecturally uniform, though the row houses shared a similarity as they were built of red brick, three stories in height and built in the 1840s and early 1850s. Facing the Public Garden, which was laid out in 1837 on filled land, these houses would see changes in the early twentieth century with Colonial Revival details, especially windows and orioles, and the building of the Bayard Thayer House (now the Hampshire House), the Sears House (now the Greek Consulate) and high-rise apartment buildings. 77 Beacon Street is the building on the left with a first-floor oriole.

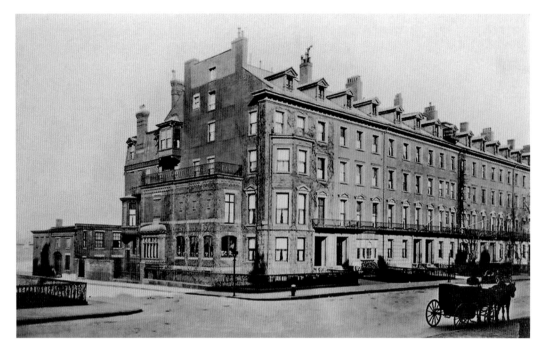

This row of houses on Beacon Street were designed by George M. Dexter and ran from Otter Street (now the David G. Mugar Way) on the left to Beaver Street facing Arlington Street and the Public Garden. Their shared height, setback, design and building material made it a cohesive streetscape, with a cast-iron balcony along the piano nobile. 95 Beacon Street was the Winsor School, founded in 1886 by Mary Pickard Winsor, the headmistress, who lived next door at 96 Beacon Street; in 1910, the school moved to the Fenway. The Noble and Greenough School, operated by George Washington Copp Noble and James J. Greenough, was located at 97 Beacon Street. Those houses on the left were demolished in 1950 for David G. Mugar Way.

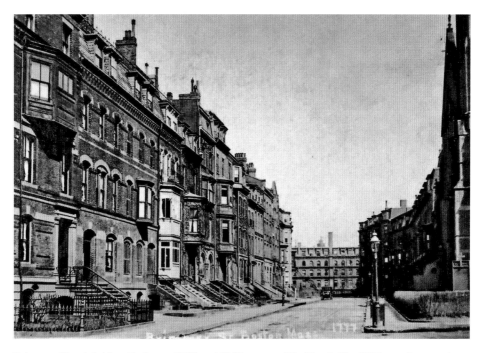

Brimmer Street, laid out between 1828 and 1866, was on filled land. The 1860s row houses share a uniformity of height, setback and design and each has a projection oriole that creates a visually interesting streetscape. Richard A. Fisher designed the row houses at 50 to 58 Brimmer Street. On the right is the Church of the Advent, designed by John Hubbard Sturgis and Charles Brigham and completed in 1888 as one of the grandest English Gothic Revival churches in the city. The Advent states that they have always striven to witness to "the beauty of holiness and the holiness of beauty," acquiring a worldwide reputation as a "shrine church" of Anglo-Catholicism in the United States.

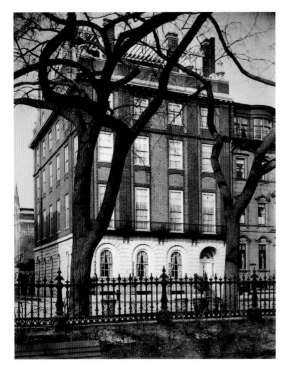

The Thayer Townhouse was designed by Ogden Codman and built in 1910 at the corner of Beacon and Brimmer Streets for Bayard Thayer, a noted horse breeder and racer, dog breeder, yachtsman and horticulturalist. The house later became the Hampshire House and had a bar known as the Bull & Finch in the basement that was opened in 1969, which inspired the long-running NBC hit comedy series *Cheers*. In the early 1980s, producers selected this neighborhood basement pub, as the inspiration for the show. A well-known and popular neighborhood bar, it has since become a destination for tourists and the television show's many fans.

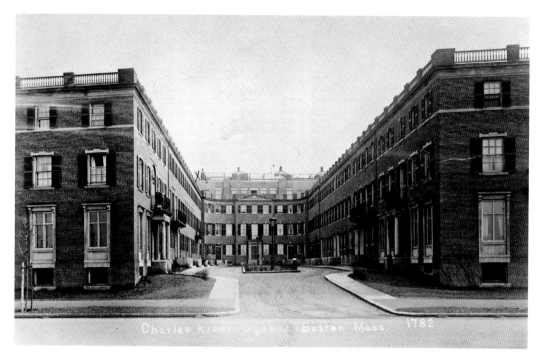

Charles River Square is a *cul-de-sac* on the Flat of Beacon Hill that was designed by Frank A. Bourne in 1916. The name Charles River Square was suggested by Annie Adams Fields whose house, filled with memories of literary Boston, was adjoining and whose garden is now known as Annie's Garden. T. Russell Sullivan in his book, *Boston Old and New*, said of the Square, "that modern example of the good which may be wrought by artistic house-grouping, as successful in its simple way as the mellow crescent of an English Georgian town." With columned entrances, roof balustrade and center pedimented pavilion, the facades of these neoclassical townhouse shares that of its adjoining townhouses in a crescent facing the Esplanade and the Charles River. [*Author's Collection*]

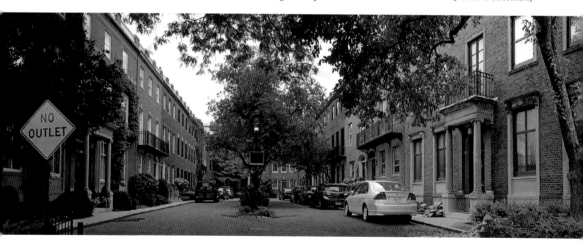

Looking from an arch to West Hill Place, the row houses were designed by Coolidge & Carlson, Architects as impressive red brick Georgian houses set in a circular court and built in 1917, with a view towards the Charles River. The development was named for West Hill, a high bluff west of West Cedar Street. The houses, built on the site of the Home for Aged Women, were inspired by the "Post-Colonial homes on Beacon Hill, and although the interiors of no two houses are alike, a general symmetry of exterior design has been maintained throughout the group." The design of these houses—with their high-style neoclassical details, demilune fanlights and side windowed entrances, corner quoining, roof urns and elegantly restrained design—made it seem as if London had been transplanted in Boston.

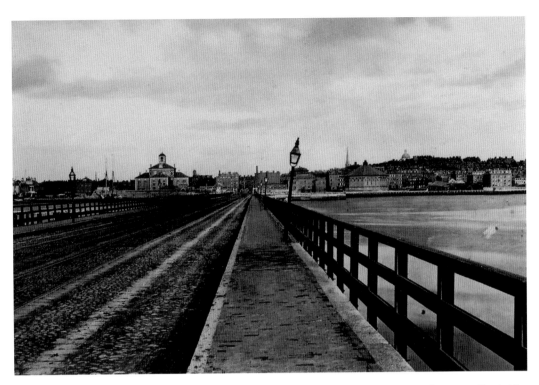

The West Boston Bridge spans the Charles River, connecting the cities of Cambridge and Boston at Cambridge Street, now known as Charles Circle. This *c.* 1880 photograph shows the Massachusetts General Hospital and the Charles Street Jail on the left and the dome of the Massachusetts State House rising above the roof line of Beacon Hill houses on the right. James Jackson Storrow said that the Charles River Basin, seen on the right, was "one of the noblest pieces of city planning in the world." [*Author's Collection*]

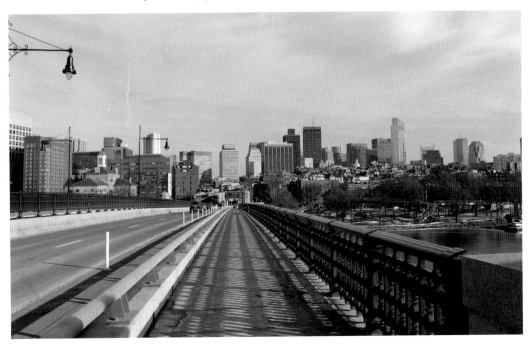

The apartment complex at 107-109 Chestnut Street was designed by William Chester Chase and built in 1900 at the foot of Chestnut Street overlooking the Charles River Embankment, now David G. Mugar Way. Built as a Neo-Federal stucco apartment house with an unusual floor plan and a multitude of windows, it had Classical Revival details such as Bulfinch's recessed arched windows as well as a red tile roof.

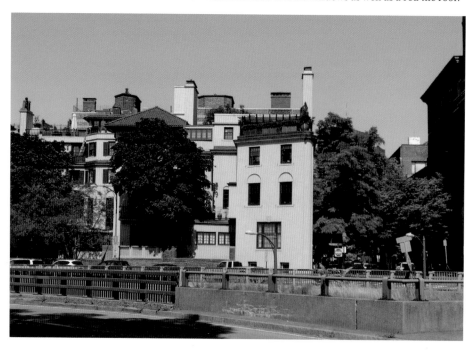

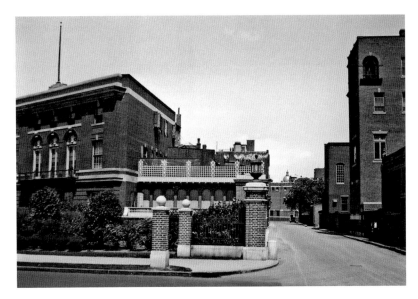

The Union Boat Club was founded in 1851 in "a single rented room of the Braman's Baths near the Southwest corner of Brimmer and Chestnut Streets." When created, the club's sole purpose was as a pier that would allow the *Union*, the club's only boat, to be pulled out of the Charles for easy repair. The clubhouse was designed by Parker, Thomas and Rice, whose designs were known for their versatility in a diversity of historic styles of the Beaux Arts verging on English Classicism, and was built in 1910 at 144 Chestnut Street. The club is the longest continuously operating rowing club in Boston and their Shellhouse, designed by Walter P. Henderson and built in 1909, is on the Boston Embankment, now called the Esplanade. Notice the gilded dome of the State House in the distance.

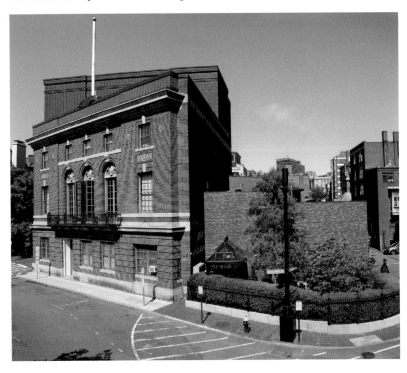

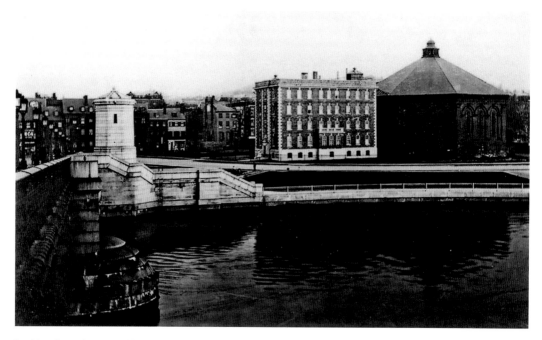

Looking from the Longfellow Bridge with its parade of back cast iron lamps, with one of the iconic Salt and Pepper Shakers on the left, the area of Charles Circle is seen in the early twentieth century on the Flat of Beacon Hill. The elegant Massachusetts General Hospital Nurses' Residence (now the equally elegant Whitney Hotel) is seen in the center and was built in 1909 as a nurses' residence by the hospital. The huge Boston Gas and Light octagonal gasometer to the right, on the edge of the Esplanade, would later become the site of the Charles Street Garage. The Whitney Hotel is named for Henry Melville Whitney, the founder of the West End Street Railway Company of Boston and the man who built the Boston Elevated Railway from Sullivan Square in Charlestown to Forest Hills in Jamaica Plain, fondly known to Bostonians as "the El." [*Author's Collection*]

4

THE NORTH SLOPE

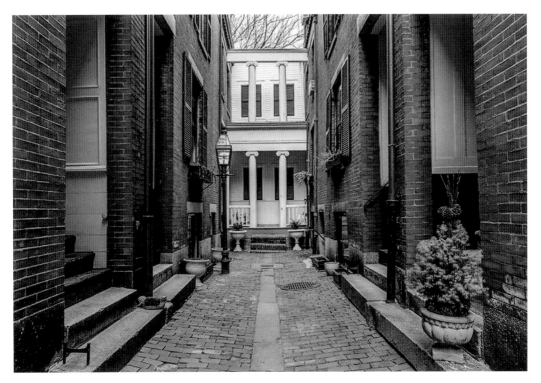

On Beacon Hill, behind an iron gate and gas streetlamp, at the dead end of a private cobblestone way lined with mid-nineteenth century brick rowhouses, is a white, two-story, columned Greek revival house with black shuttered windows. The shallow porch is actually a faux facade. "The charming house front is merely a wooden facing to a brick wall," George F. Weston Jr. explained in his book *Boston Ways: High, By and Folk*. "Its humane but prosaic purpose is to keep the wandering wayfarer from carelessly walking off the 40-foot cliff that lies behind it." The North Slope had narrow courtyards such as Bellingham Place, Sentry Hill Place, Goodwin Place and Rollins Place seen here, built in 1843 by John Rollins, which were home to artisans, tradesmen and laborers who occupied the houses.

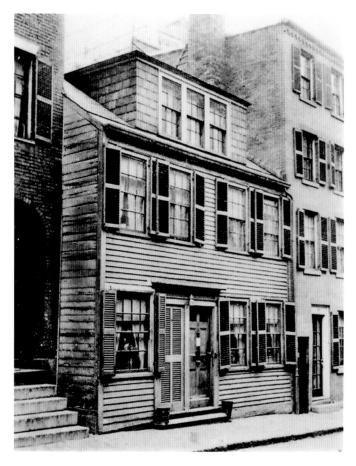

One of the oldest surviving houses on Boston's Beacon Hill is the Middleton-Glapion House at 5-7 Pinckney Street, which is built of wood and clapboarded. The house has two street numbers, because it was originally home to two bachelor friends: George Middleton, a black liveryman and a veteran of the Revolutionary War who had led the all-Black company called the Bucks of America, and Louis Glapion, a mulatto barber from the French West Indies, who used his half of the house for his barber shop. The property was purchased by the two men in 1786. The oldest house on Beacon Hill is the Ditson-Lee House at 45 South Russell Street, built in 1797.

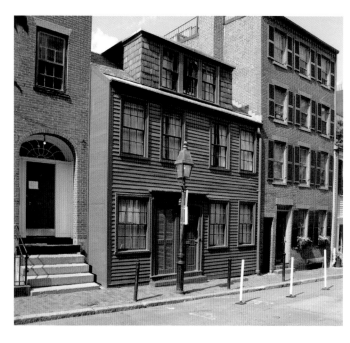

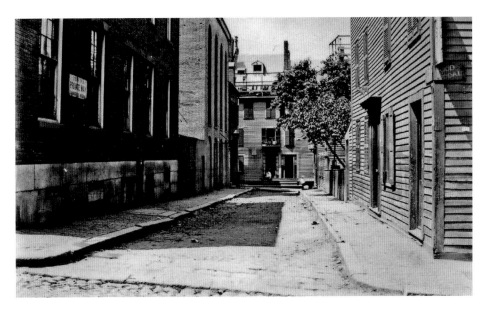

As early as the 1790s, African Americans began to move to the North Slope of Beacon Hill, which runs from Myrtle Street to Cambridge Street. The area of lower Joy Street and Smith Court was an important center of Boston's nineteenth Black community. Today, the historic homes on Smith Court, along with the First African Baptist Church and the Abiel Smith School, are the best-preserved buildings to help understand the history of African Americans in Boston. The Abiel Smith School, on the left, educated African-American children from 1835 to 1855. The First African Baptist Church, also on the left, was founded under the leadership of Thomas Paul and is now referred to as the African Meeting House.

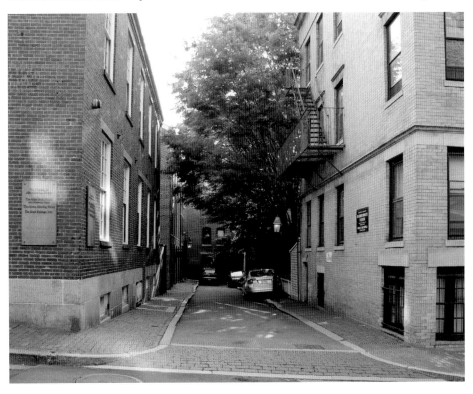

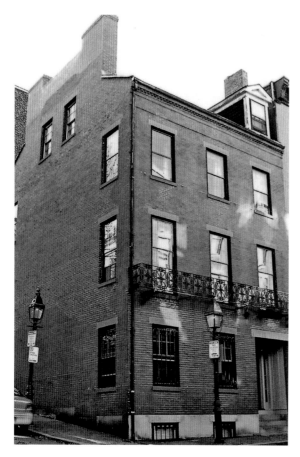

Left and below: John P. Coburn, a well-to-do African American and owner of the W. T. Coburn Clothing Store and community activist in the New England Freedom Association, lived at 2 Phillips Street from 1844 until his death in 1873. This home was the second owned by Coburn on Beacon Hill and it was designed for him by the famous architect Asher Benjamin with a design drawn from his book *The American Builder's Companion.* He also had a gaming house for wealthy Bostonians in his home, an area which was also a station on the Underground Railroad, the network of homes, churches, and other establishments where runaway slaves were hidden, fed, and clothed as they fled to freedom.

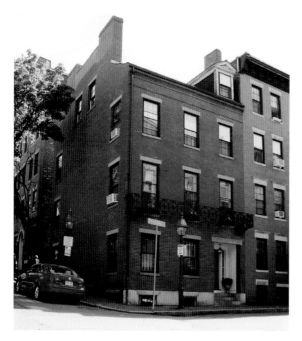

On the next page: Joseph Lee, Jr. once lived on the top floor of this house at the corner of Anderson and Myrtle Streets on Beacon Hill in the 1930s. It was on the roof of this building that he and his nephews Kenny and Donny Robertson crafted the first prototype of his design for a sailboat that was launched on the Charles River Basin in 1936. Lee was the founder of Community Boating on the Charles River which promoted "Boating for All" and where he encouraged and taught the rudiments of sailing to the city youth, and public sailing on the eventual seven-boy-built fleet which was the result of Lee's vision. Today, the ground floor of the building is the Beacon Hill Market.

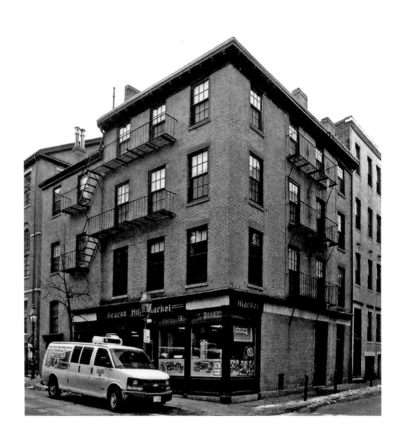

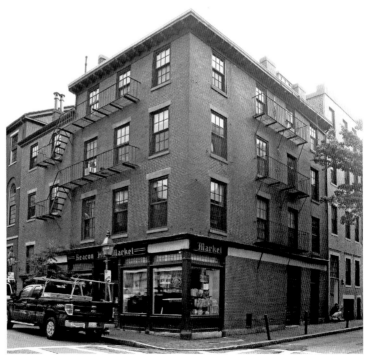

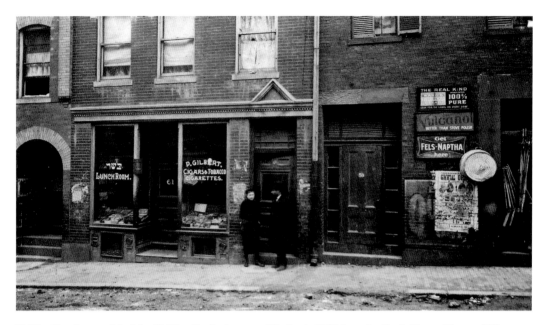

Phillips Street, named for John Phillips, the first mayor of Boston in 1822, is on the North Slope of Beacon Hill. Seen here in a photograph from 1909 is 61, on the left, and 59 Phillips Street, near Grove Street, with two men standing in the doorway to the four-story tenement with apartments above. P. Gilbert's Kosher Deli and Lunch Room, which also sold cigars, tobacco and cigarettes, was typical of the small shops catering to the neighborhood residents. Above were apartments that house a multi-ethnic, multi-racial neighborhood with new immigrants and their children; on the upper right is a ceramic pitcher on the windowsill to keep milk cool without an icebox.

The North Slope of Beacon Hill, which
was a multi-ethnic and multi-racial
neighborhood of residences, places
of worship and businesses. Some
of the tenements built between
1890 and 1920 had on the ground
floor delicatessens and cafes with
Yiddish lettering on the windows that
offered Kosher foods for the many
Jewish residents. This is the Lunch
Room and Kosher Delicatessen at 57
Phillips Street at the corner of Grove
Street. The five-story tenement has
an impressive swag-pressed metal
rectangular oriole projecting from
the side of the building, and the
window lintels are each of a different
design, all of which adds architectural
details at low cost. On the far right
is the facade and conical tower of
the Twelfth Baptist Church at 43-47
Phillips Street, built in 1895.

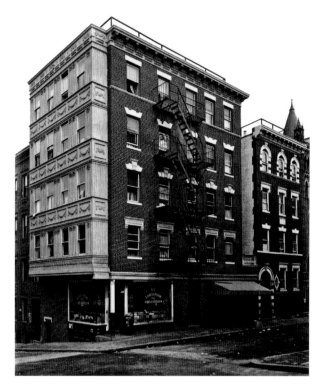

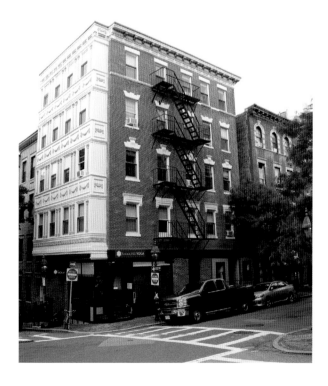

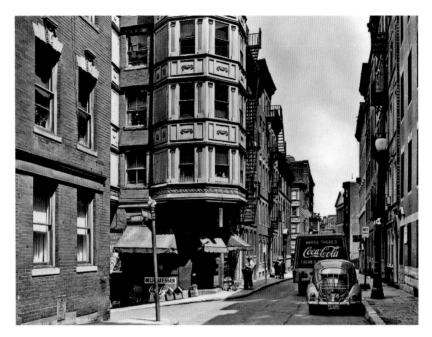

63 Myrtle Street at the corner of Garden Street was a five-story tenement with a delicatessen in the corner shop. William A. Clarke, Charles A. Halstrom and Fred Norcross were the principal architects who rebuilt the North Slope of Beacon Hill between 1893 and 1929. Typical of their designs were the pressed metal bays with reeded pilasters and swags, which were impressive and added architectural interest to an otherwise simple brick tenement. On the left is 69 Myrtle Street, and just beyond is the Bowdoin School, now condominiums, and Beacon House, now affordable housing for Boston elders. Notice how narrow Myrtle Street is; it was never intended to have parked cars or large Coca Cola delivery trucks.

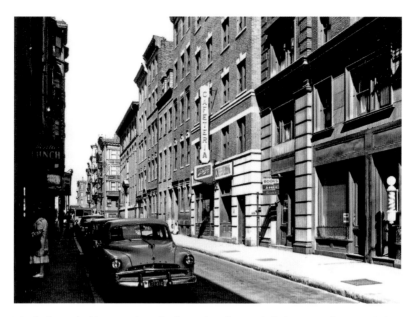

Myrtle Street, looking west from Joy Street, has the Myrtle Cafeteria on the ground floor of 27 Myrtle Street, and on the right is the eight-story Beacon Chambers, which had shops on the ground floor including the Pilgrim Laundry, a book shop and a barber shop on the right. The Beacon Chambers, designed by Herbert Hale and built in 1900 as bachelor apartments by the Beacon Chamber Trust "for the use of students and other young men who desire attractive and clean living accommodations at moderate cost," was renovated by Chia-Ming Sze Architects for Rogerson Communities as mixed-income housing with apartments, studios and community spaces located at the ground level.

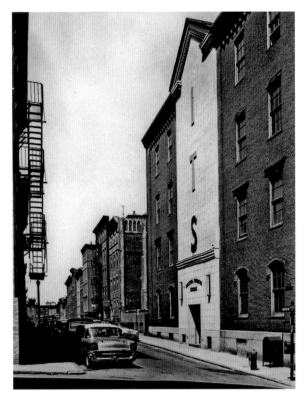

The Northeast Institute of Industrial Technology was at 41 Phillips Street at the corner of Anderson Street and was a technical school that taught students to maintain security, air conditioning and heating equipment. Opened in 1942 by George Galvin and John Hoffman, the Northeast Institute started near Northeastern University and moved to Beacon Hill in 1947, occupying the former Wendell Phillips School, which was closed in 1940 and had the WPA located here afterwards. At its height in the 1980s, the Northeast Institute enrolled 400 students in day and evening classes. Today, it is Phillips Square Condominiums.

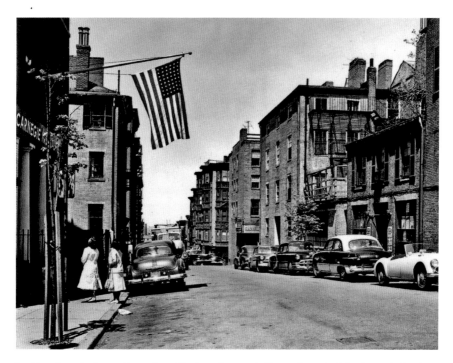

Looking down Anderson Street from Pinckney Street, the Boston Branch of the Carnegie Institute is seen on the left with an American Flag flying from a flagpole. Founded by philanthropist Andrew Carnegie, the institute was established as a unique organization dedicated to scientific discovery "to encourage, in the broadest and most liberal manner, investigation, research, and discovery and the application of knowledge to the improvement of mankind … " and it was incorporated by the United States Congress in 1903. The institute occupied the former English High School which was built in 1824, and which was later used as the Phillips School and the Sharp School.

5

PLACES OF WORSHIP

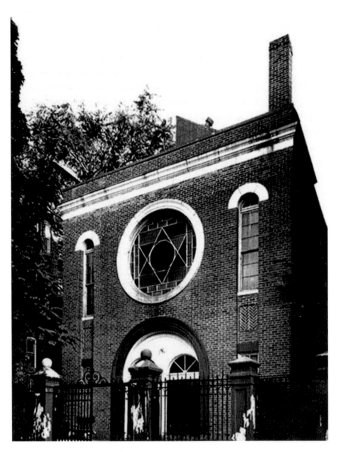

Vilna Shul was built in 1919 by immigrants and their children from Vilna, Lithuania, and above the doorway are the words "Vilna Congregation" in Yiddish characters. Jews in Boston often united around their towns of origin into mutual aid societies call *Landsmanschaften*. The orthodox synagogue was designed by Boston architect Max Kalman and is the last of the purpose-built immigrant synagogues still standing in downtown Boston at the end of the twentieth century. Today, it is still a place of worship, but also the Vilna Center for Jewish Heritage, which was founded to raise funds to preserve and restore the synagogue for use as a Jewish cultural heritage center.

The Church of St. John the Evangelist was designed by Solomon Willard and built in 1831 for the Bowdoin Street Congregational Society, which was led by the Rev. Dr. Lyman Beecher. An impressive granite Gothic Revival-style church with a crenelated tower, it was later occupied by the Church of the Advent from 1863 to 1883, after which it became the Mission Church of St. John the Evangelist under the auspices of the Society of St. John the Evangelist, an Anglican monastic order. In 1985, the church became a parish in the Episcopal Diocese of Massachusetts but was closed in 2015 and repurposed as a condominium complex known as the Victoria Residences.

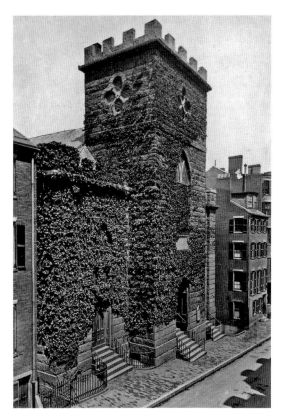

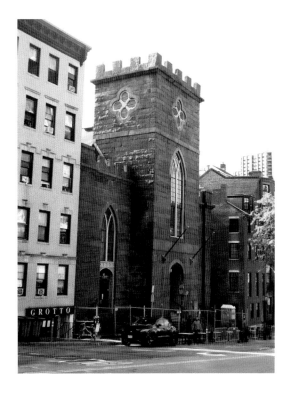

Left and below: The African Meeting House on Beacon Hill in Boston was built in 1806 to house the first African Baptist Church of Boston, known as the First Independent Baptist Church, and is now the oldest Black church edifice still standing in the United States; it also hosted political and anti-slavery meetings by the Anti-Slavery Societies. Seen here in the 1930s, it was then the Anshei Libovitz Synagogue, founded in 1890. The congregation moved to the former meeting house in 1892, and seen on the corner is a sign with two Hebrew words at the top, *beit Knesset*, meaning synagogue. The middle three words spell out in Yiddish characters the words "Congregation Anshei Libowitz." The term *Anshei* means "men of," so this congregation was founded by people from Libowitz in Russia, remained active till 1972 and subsequently, became the African American Heritage Museum.
[*With thanks to Jeff Rubin*]

On the next page: The Charles Street Meeting House was designed by Asher Benjamin and built in 1807 as the Third Baptist Church of Boston at the corner of Charles and Mount Vernon Streets. In 1876, the church was sold to the First African Methodist Episcopal Church, incorporated in 1833. They worshiped here until 1939 when it was sold to the Charles Street Meeting House Society, and the Charles Street AME relocated to Roxbury, and was rented to an Albanian Orthodox congregation. It served as a Universalist Church of America from 1949 to 1961, and as Unitarian Universalist after consolidation, from 1961 to 1979. The meeting house saw creative adaptive reuse in the early 1980s by the architectural firm of John Sharrat Associates, who repurposed the church into four floors of offices, with shops on the ground floor.

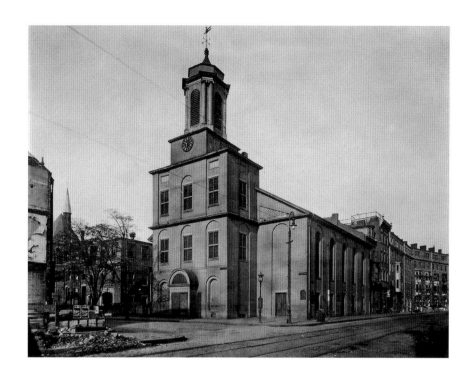

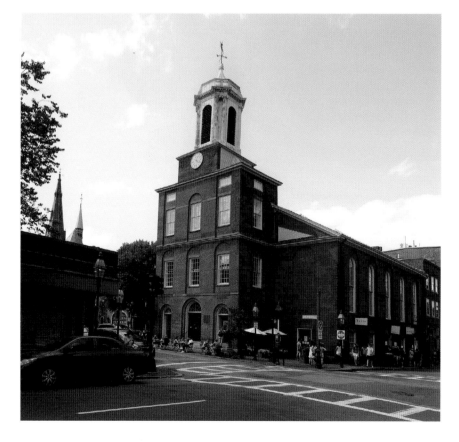

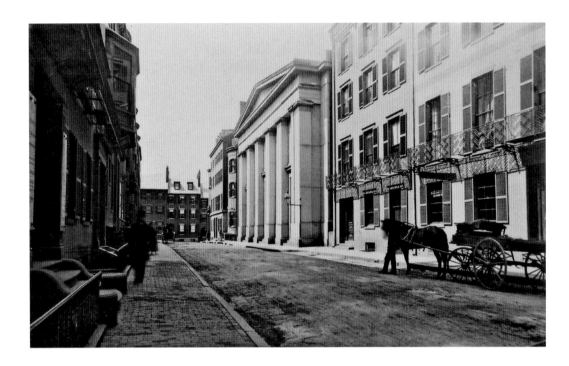

The Mount Vernon Church, named for Mount Vernon, one of the three hills of Boston and known as the Trimount, was designed by architect Richard Bond and built in 1843 on Ashburton Place, originally known as Somerset Court until 1845, in what was then a fashionable residential neighborhood. The church was built of smooth faced granite and was in a severe, unornamented Greek Revival temple-fronted building with six square pilasters supporting a pediment. The dimensions of the church were seventy-five feet by ninety-seven feet deep, with 132 pews on the lower floor, and fifty in the gallery, in which just over 1,200 people could be comfortably seated.

On the next page: Built in 1843 as the Millerite Church, a group of Adventists who were led by Reverend William Miller, who believed in the impending end of the world. Their anticipated ascension to heaven was thwarted when the day of reckoning in 1844 never came. In 1845, the church was sold and redesigned as a theater, but was destroyed by fire and rebuilt as the Howard Athenaeum, designed by Isaiah Rogers.

Continued from previous page:
An impressive Gothic Revival design of Quincy granite, it had a large auditorium above that seated 1,300 patrons. The Howard Athenaeum, a fairly unusual name for a theater that had no books, presented serious entertainment to Bostonians including Italian operas *Armeda* by Rossini, *Ernani* by Verdi, *Don Pasquale* by Donizetti and *Don Giovanni* by Mozart. The years prior to the Civil War had people coming to Howard Street to enjoy music, opera and other serious programs that befitted an athenaeum with "opera, tragedy, comedy, burlesque, vaudeville, minstrels and magicians."

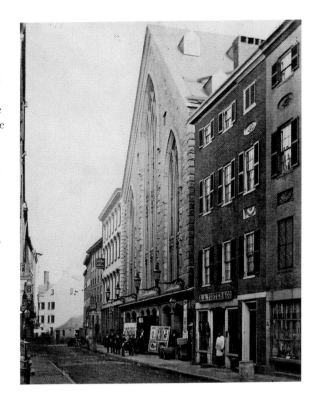

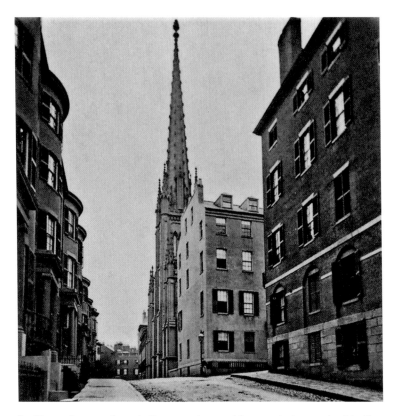

Looking up Somerset Street in Boston, at the top of the street is the steeple of the First Baptist Church, founded in 1665, seen at the corner of Ashburton Place. Built in 1858 as a Gothic Revival church of brick covered in mastic, its spire was 200 feet high.

Continued from previous page: As the neighborhood
became increasingly commercial, the First Baptist
Church would in 1877 move to the South End, when the
Shawmut Avenue Baptist united with First Baptist and
worship was conducted in the Suffolk Street Chapel
at the corner of Shawmut Avenue and Rutland Street
in the South End. In 1882, the First Baptist Church
purchased the new Brattle Square Unitarian Church
designed by H. H. Richardson at Commonwealth
Avenue and Clarendon Street in the Back Bay. In 1882,
the Somerset Street church became Boston University's
College of Liberal Arts.

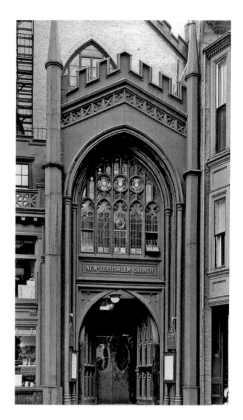

Right and below: The Swedenborgian Church of Boston,
the Boston Society of the New Jerusalem was organized
in 1818 and the church met at several locations before
finally building a Gothic church in 1845 at its present
location on Bowdoin Street on Beacon Hill. The church
is an open-minded, forward looking Christian church,
drawing its faith from the Bible as illuminated by the
teachings of Emanuel Swedenborg. A beautiful chaste
Gothic Revival structure with a crenelated entrance,
it served the congregation until the mid-1960s when
it was replaced with a new church, an eighteen-story
apartment building and an underground parking garage.

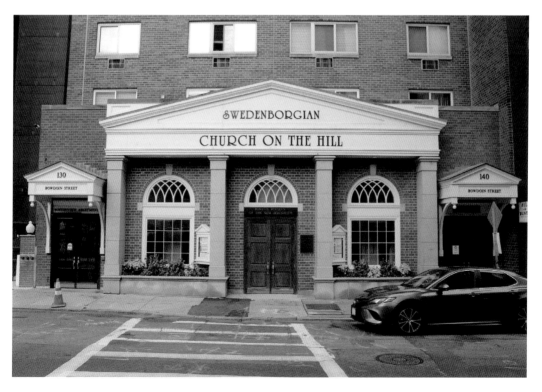

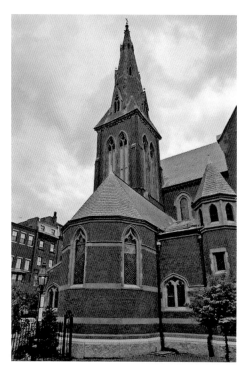

The Church of the Advent, with its soaring 172-foot spire, was designed as an English Gothic Revival church by John Hubbard Sturgis and Charles Brigham and completed in 1888 at Brimmer and Mount Vernon Streets. The congregation was founded in 1844 and has long been one of the leading Anglo-Catholic parishes in the American Church. Its strong adherence to the principles of the Oxford Movement makes it a parish whose name is recognized throughout the world as an icon of Anglo-Catholicism in America. The High Altar with its Caen stone reredos was designed by Harold Peto of Peto and George in London, and was the gift of Isabella Stewart Gardner. One wit said the church was a "Red brick Victorian [church], not particularly interesting on exterior. Once inside, however, one feels one's died and gone to England." [*Author's Collection*]

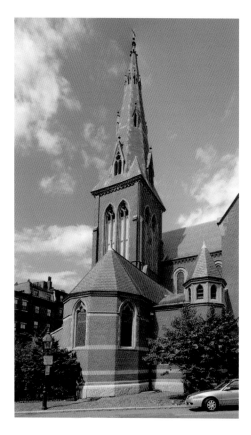

In 1886, the Boston University School of
Theology moved to 70-72 Mount Vernon
Street, and renamed the houses as "Warren
Hall" in honor of William Fairfield Warren,
the college's first president. In 1916, the
School of Theology added Robinson Chapel,
named for Roswell R. Robinson, to the rear of
Warren Hall, on Chestnut Street. When the
school relocated to the Charles River Campus
in 1950, stained glass was removed from the
chapel and used in the new construction of
the School of Theology and Marsh Chapel on
Commonwealth Avenue. The former chapel
was converted to condominiums in the 1960s.
On the left is 29A Chestnut Street.

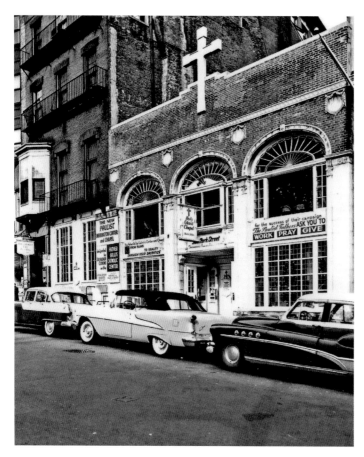

The Holy Ghost Chapel of the Paulist Fathers, a Roman Catholic religious order of priests, came to Boston in the late 1940s. With the enthusiastic support of Boston's Archbishop, the Paulists established what was then called a "Catholic Information Center" and chapel on Park Street in a former row house that had been converted for commercial use by the Waldorf Restaurant, Zinn Florist Shop and the Germania Co-Operative Bank. In the mid-1950s, the Church built the present structure of the Holy Spirit Chapel, classrooms and office space. Today's Paulist Center Community "continues many of these initiatives, always seeking to adapt to the needs of our time according to our capacity."

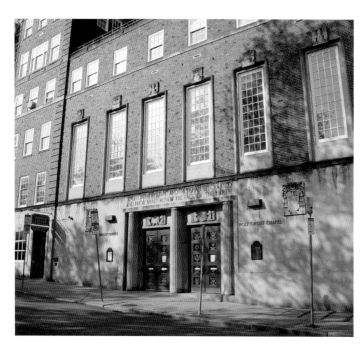

6

THE TWENTIETH CENTURY

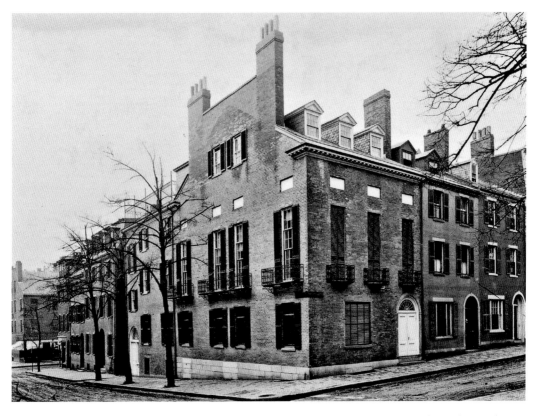

The Harvard Musical Association is a private organization that was founded in 1837 by graduates of Harvard College for the purposes of advancing musical culture and literacy, both at the university and in the city of Boston. In 1892 the Association acquired the Malcolm Scollay Greenough house at 1 West Cedar Street, and the first concert opened with a concert by Antonín Dvor˘ák, a Czech composer and one of the first musicians to achieve worldwide recognition and who wove the rhythms of the folk music of Moravia and his native Bohemia into his music. The Harvard Musical Association still maintains a longstanding tradition of commissioning new works, supporting local non-profit musical organizations, giving prizes and awards to young performers and presenting chamber music performances to members and their guests.

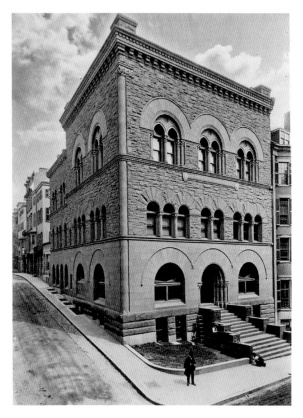

The American Unitarian Association
Building was designed by Peabody and
Stearns and built in 1886 at the corner
of Beacon and Bowdoin Streets. An
impressive granite Romanesque Revival
building, it had a center entrance with
a flight of stairs flanked by windows
in multiple arches on the facade. The
smooth granite of the ground floor was
topped with hammered granite blocks
and banks of arched windows. Robert
Swain Peabody and John Goddard
Stearns were leading architects in Boston
in the late nineteenth century. The
Bellevue Hotel, also designed by Peabody
and Stearns, was later built on the site
as a grand hotel, which is now a luxury
condominium building.

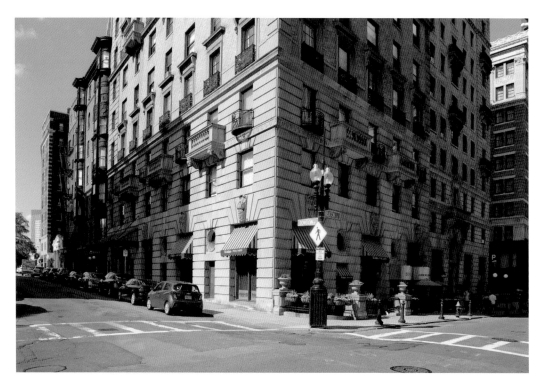

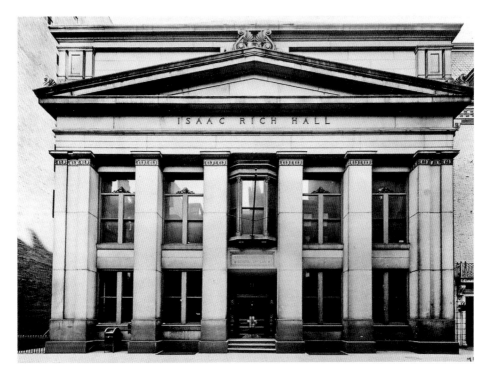

Isaac Rich Hall of Boston University was named for one of the three founders of the university who also included Lee Claflin and Jacob Sleeper. Originally the Mount Vernon Church, it became the Boston University School of Law in 1895 and the school would remain on Ashburton Street until 1964. Isaac Rich had opened an oyster stall in Faneuil Hall Market and through real estate speculation would become immensely successful. Rich became one of the most prominent Methodist laymen, and his philanthropies were chiefly in connection with educational institutions of the Methodist Episcopal Church and Boston University.

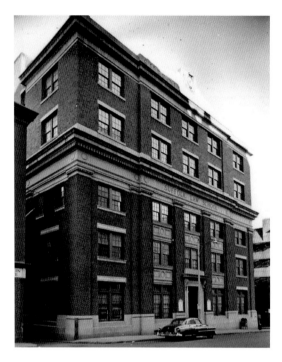

In 1906, Gleason Archer founded Suffolk University Law School, first known as Archer's Law School and originally located at 6 Alpine Street in Roxbury. Archer's goal was to build an evening law school which would provide a law education regardless of economic class, race or religion. The school started off in Archer's home at night, but eventually was relocated to Archer's law offices in Boston. In 1915, Archer wrote a book titled *The Educational Octopus* detailing the various difficulties surmounted in founding the school and the strong opposition from Harvard University. By 1930, Suffolk Law School was one of the largest law schools in the United States. Archer founded The Suffolk College of Arts and Sciences in 1934, and in 1937 the Sawyer School of Management, then known as the College of Business Administration. Suffolk University's Gleason L. & Hiram J. Archer Building at 20 Derne Street would later be sold and repurposed as the Archer Residences, luxury condominiums.

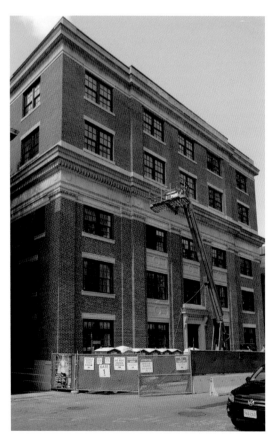

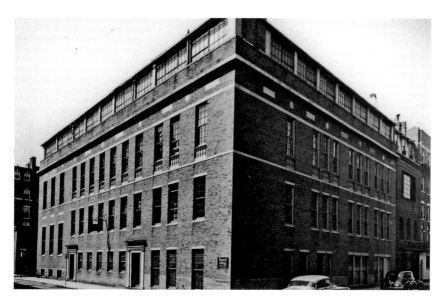

Burdett College of Business and Shorthand was founded in 1879 by Charles A. Burdett. The school's motto was "Actual business from the start," and the college used a system patented by Burdett. From a small private school at the corner of Washington and Boylston Streets, Burdett College grew into an institution of many schools incorporated into one big influential unit. The preparation of young men and women for positions of executive grade is the new work of Burdett College. Originally the Brimmer School, the Burdett School of Business Administration was relocated to 69 Brimmer Street, which in 1970 became Emerson College First Level Program and is now the Park Street School. [*Author's Collection*]

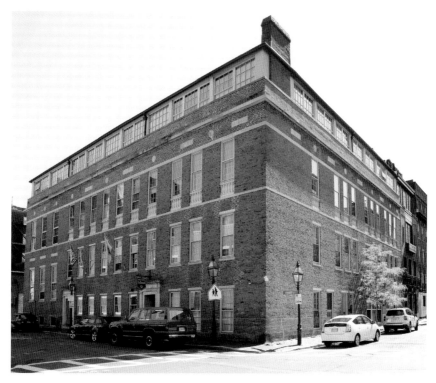

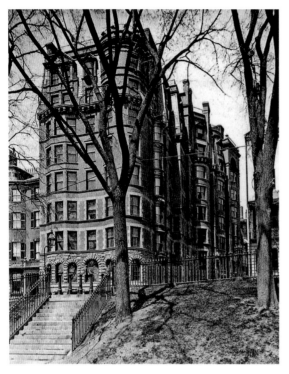

"The Tudor" was designed by Samuel J. F. Thayer and built in 1887 at the corner of Beacon and Joy Streets on the site of Frederick Tudor's mansion. Known as the "Ice King" of Boston, he was the founder of the Tudor Ice Company and a pioneer of the international ice trade in the nineteenth century. The Tudor is eclectic; Keith Morgan describes the building: "[the] quarry-faced sandstone base remains Romanesque, while the five stories above combine the traditional Boston bow front with Queen Anne oriel windows." The Tudor is a nine-story building and so close to the State House that it led to a lawsuit on height restrictions on Beacon Hill. For much of the twentieth century, The Tudor housed both apartments and offices and in 1999, it was renovated and converted into seventeen luxury condominiums. [*Author's Collection*]

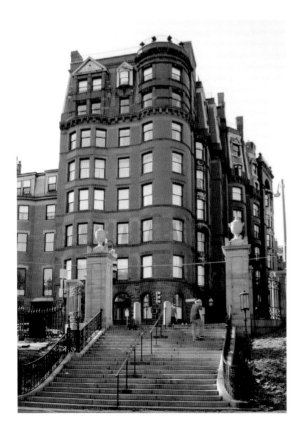

"The Lincolnshire" is at 20 Charles Street and extends back to River Street. Developed by William Coombs Codman of the West End Associates and opened in 1925, it was both a transient as well as a residential hotel and offered "artistically and substantially furnished suites of living room and one or more bedrooms and bath" and a squash court and a small gymnasium which was located on the roof. Later, the Massachusetts General Hospital owned the building and used it for nurses' dormitories and later for doctors' offices. Today, this is the Lincolnshire Residences, luxury condominiums. [*Courtesy of Historic New England*]

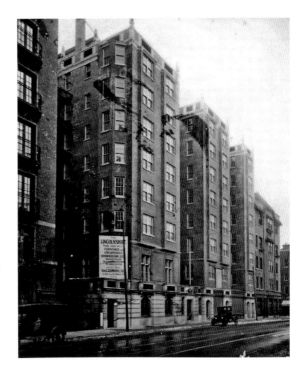

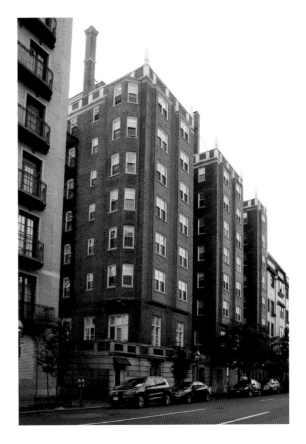

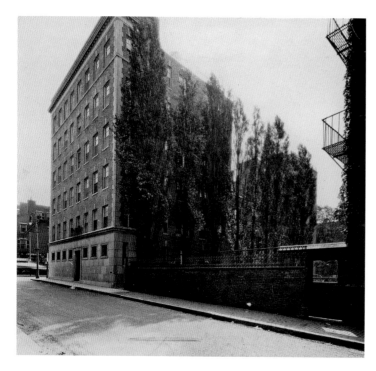

112 Revere Street is
a six-story luxury
apartment building built
at the corner of Charles
Street. Built of red brick
and limestone with corner
quoining, it represented
the new interpretation
of apartment living in
the city, with commercial
space on the ground floor
facing Charles Street.
[*Author's Collection*]

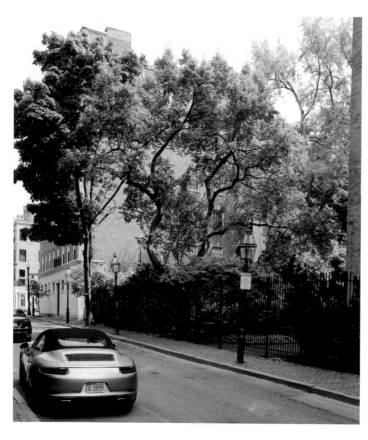

CHARLES CIRCLE AND CAMBRIDGE STREET

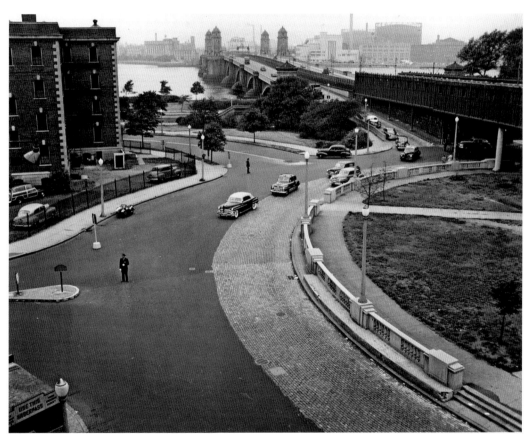

Charles Circle, seen in 1949 at the end of the Longfellow Bridge, had been reconfigured as a major interchange along Storrow Drive, and to accommodate increases in traffic volume, two overhead ramps were built to connect the expressway with the circle. The Red Line of the MBTA crossed from Cambridge in the center of the bridge, with its four distinctive towers referred to as the "Salt and Pepper Pots," and Charles Street Station can be seen on the right. On the left is the Nurse's Residence of Massachusetts General Hospital now the Whitney Hotel. By the 1950s, Charles Circle was a jumbled mess of infrastructure, a swamp of traffic congestion and a hazardous pedestrian wasteland. [*Author's Collection*]

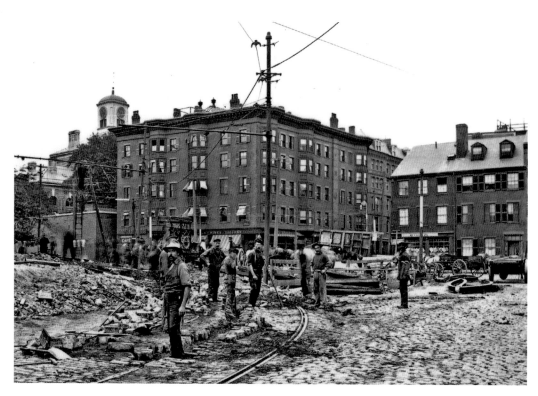

The Charles Street Loop was far different a century ago. The intersection of Charles and Cambridge Streets had streetcar tracks that used the loop to return towards Scollay Square, and then onto Maverick Square in East Boston. The huge apartment house in the center and the one to its right on Cambridge Street were built in the late nineteenth century and were removed when Cambridge Street was widened in the 1920s. On the right are nineteenth-century brick row houses on Charles Street, now commercial space and apartments. Notice the clock in the cupola on the left of the Charles Street Jail, possibly signifying time well and productively spent by the inmates.

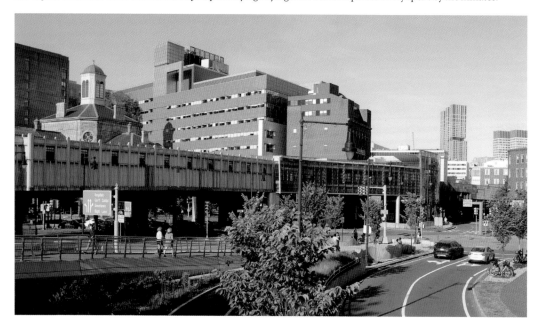

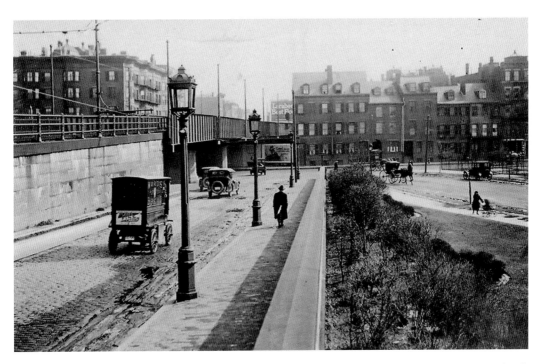

The Red Line of the MBTA originally connected Harvard Square in Cambridge and Andrew Square in South Boston and was named for the crimson of the Harvard University connection, thus it became known as the Red Line. The Charles Street Station was an important one as the Massachusetts General Hospital, the Massachusetts Eye and Ear and the Charles Street Jail were all accessible from this station. In 1932, the Metropolitan Boston Transit Authority granted them access with the construction of Charles Street Station over a circular island in the middle of the intersection, from which Charles Circle derives its name.

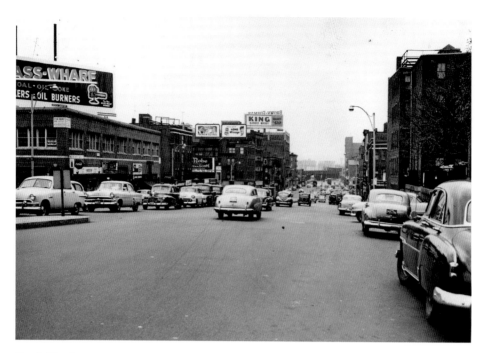

Cambridge Street, seen in 1953 looking west towards the Charles Street Station, had a commercial overlay of the nineteenth and early twentieth centuries. On the left is Hancock Street with a streetscape of commercial buildings, apartment buildings with shops on the ground floor and huge billboards surmounting the roofs of many of the buildings. Cambridge Street was a direct connector to Cambridge and points west, widened to alleviate traffic congestion problems, beautify the river along the Charlesbank and the greater Charles River Embankment, and provide subway rail access across the river in Cambridge. The building on the left is now Zone Fitness. [*Author's Collection*]

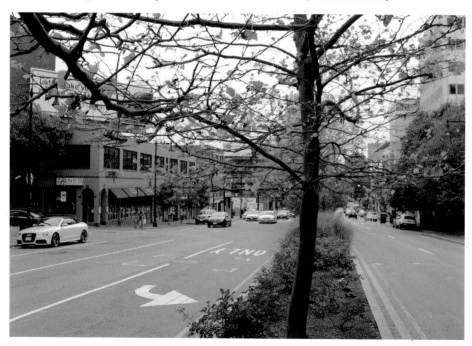

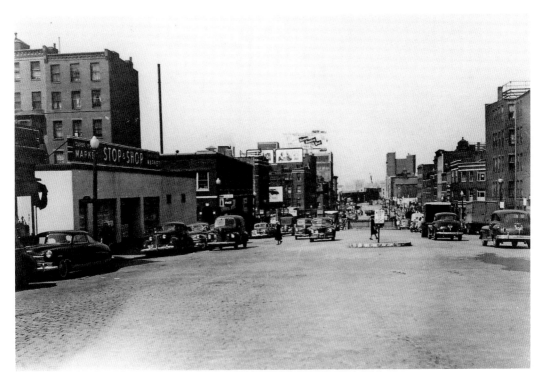

Stop & Shop, seen on the left, is a supermarket chain that was started in 1892 by Solomon and Jeanie Rabinowitz as the Greenie Store at 134 Salem Street in Boston's North End. The market was founded in 1914 by the Rabinowitz family as the Economy Grocery Stores Company. The store adopted the new self-service supermarket and were pioneers of the modern grocery store, selling all types of food items under one roof. Cambridge Street in the 1940s was the dividing line of the North Slope of Beacon Hill on the left and the West End of Boston on the right. Today, Suffolk University's Ridgeway Building is on the site of the Stop & Shop.

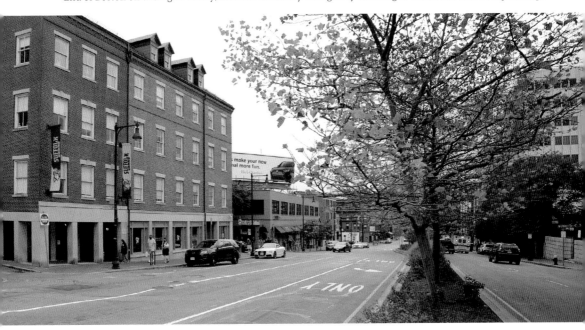

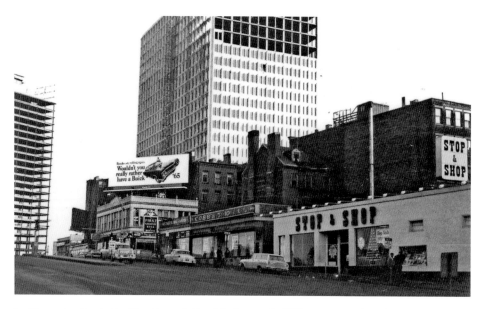

Looking east on Cambridge Street towards Bowdoin Square, the 1960s saw tremendous changes that through urban renewal changed the city. The Stop & Shop is still an anchor in the neighborhood, but the Leverett Saltonstall Building, designed by Emery Roth and Sons, is being erected in 1965 at the corner of Cambridge and Bowdoin Streets, and the John Fitzgerald Kennedy Federal Office Building, designed by Walter Gropius and The Architects Collaborative with Samuel Glaser, is being erected on the left on the edge of Boston City Hall Plaza. The North Slope of Beacon Hill was dwarfed by these new high-rise buildings in the 1960s.

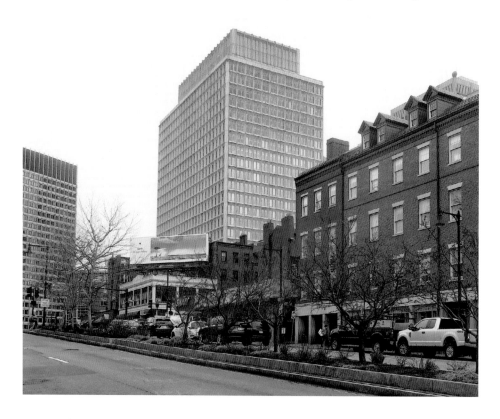

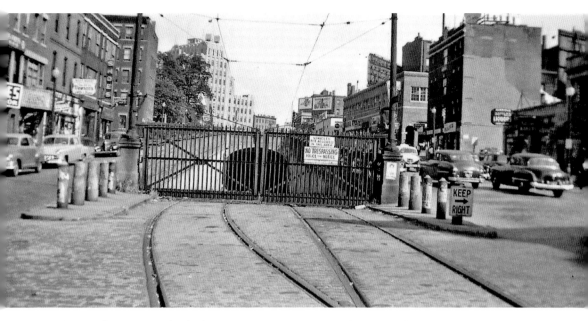

Seen in the center Cambridge Street, with Joy Street on the right, is the decline tunnel with streetcar tracks that had taken passengers into the tunnel towards Park Street. This was built during the East Boston tunnel extension in 1916, and led to the Charles Street Loop where streetcars turned, but by 1950 the line was unused and the tunnel was gated. The Art Deco New England Telephone Building at Bowdoin Square, designed by Densmore, LeClear & Robbins and built in 1930, can be seen in the distance, and a political sign on the right advocating John B. "Hynes" for mayor of Boston. [*Author's Collection*]

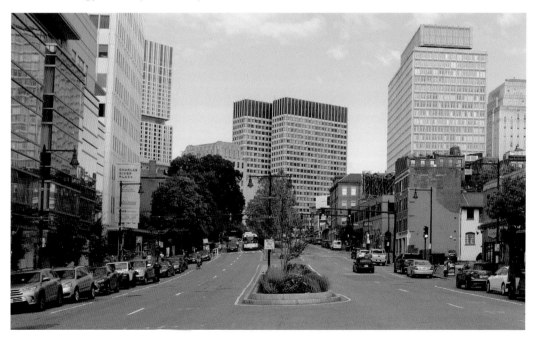

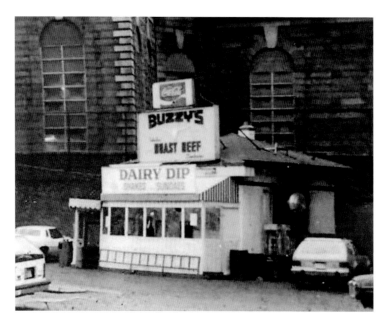

The former Flying A Service Station would give way to Buzzy's, Boston's beloved greasy spoon, that stood in the shadow of the solid granite Charles Street Jail since the early 1960s. Buzzy's was open at all hours and the order window was where Bostonians ordered not just comfort food, but were served the "flavor of Charles Circle." Buzzy's Fabulous Roast Beef, B-B-Q Rib of Beef, Hot Pastromi and knishes were advertised along with French fries, onion rings and Dairy Dip, for those heading home from shows or headed to clubs, all the while mingling with those who had no idea where they were going. In 2002, Massachusetts General Hospital bought this famous landmark and demolished it for the drive to the new Liberty Hotel.

CHARLES STREET

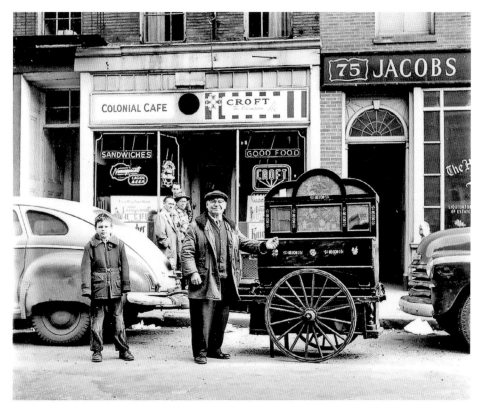

Marino Antonio Persechini is seen on Charles Street with his highly decorated barrel organ, which, owing to its use of bellows and pipes housed in a case to operate levers and play notes, was designed to be mobile enough to play its music in the street. The cylinders used held only a limited number of tunes, which could not easily be upgraded to play the latest hits, which included "My Wild Irish Rose," "Tic Toc Polka," "Down at Coney Island," "Toy Land Village," "Torna a Surriento" and "La Paloma." He recorded these tunes on a record produced by Sid Dimond Associates. The organ grinder, with his hand on the crank and devoid of his monkey, stands on Charles Street in front of the Colonial Cafe, now The Sevens Bar. On the right is the antique shop and real estate and mortgage office of William M. Jacobs, whose son, David Jacobs, the present publisher at *The Boston Guardian* is seen to the left. On the left are a few of the cafe patrons standing in the cafe doorway listening to the barrel organ music.

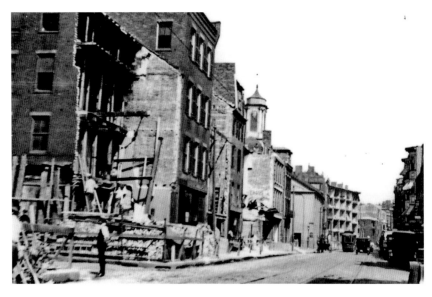

Charles Street, seen looking towards Mount Vernon Street, was being widened with the facades of the west side of the street being removed in the 1920s. This had been a years-long effort to get both Charles and Cambridge Streets widened, and a subway station at Charles Circle was opened in 1932. In the center distance is the octagonal cupola Charles Street Meeting House, designed by Asher Benjamin and built in 1804, that was spared demolition by being moved ten feet west to make room for the widening of the street. Charles Street was the edge of solid land on Beacon Hill, and with the removal of Beacon Hill in the early-nineteenth century, the carts of dirt were brought down the side of Beacon Hill as the "Flat of Beacon Hill" was filled in and built out from Charles Street, creating new man-made land.

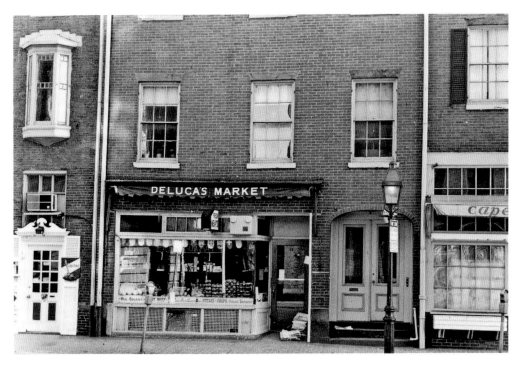

DeLuca's Market, located in the former Giuffre Brothers Fruit Store, was started by Joseph DeLuca in 1919 and the store quickly became known as "the place" in Boston for the finest in fresh fruit and produce. In 1952, DeLuca's brother-in-law, Virgilio Aiello, who had a butcher shop in the 1930s, purchased the store and added a full line of fresh meat. His son, Virgil Aiello, has since added gourmet breads, cheese and a complete beer, wine and liquor cellar.

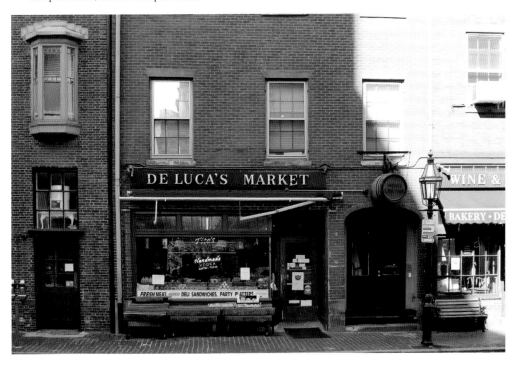

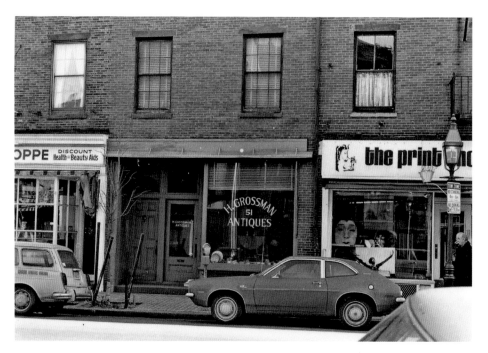

The H. Grossman Antique Shop was at 51 Charles Street. Hyman Grossman, who followed in the steps of his father Jacob Grossman, was an antique furniture dealer who scoured New England for fine examples of furniture, which he sold in his shop, and educated two generations on what fine antiques represented, all the while becoming a legend in his own lifetime. According to renowned antiques dealer Albert Sack, "You couldn't buy Hymie's integrity for all the money in the world." Charles Street was once referred to as "Antiques Alley" with Israel Sack, Jacob Grossman, Morris Kream, Philip Weiner, William Jacobs, Louis D. Prince, Roye Levin, Flayderman & Kaufman and Hyman Sacks & Sons once having antique shops here.

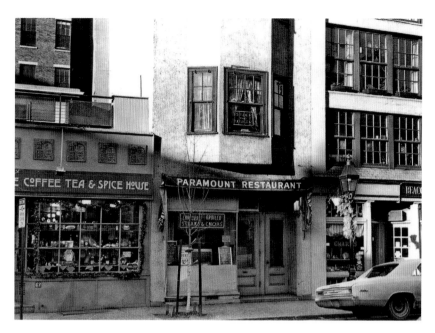

The Paramount Restaurant, with a new stucco facade after the widening of Charles Street in 1920, was opened in 1937 as the Paramount Deli and has ever since been known for its affordable breakfasts, with a line queuing almost immediately on weekend mornings. In 1995, Michael Conlon and Joe Green bought the restaurant and created a restaurant where comfort food is its specialty. *Boston Magazine* said that the Paramount "manages, quite successfully, to be everything to everyone, feeding a neighborhood of twenty something renters, deans, doyennes, and the kiddie crowd three squares a day."

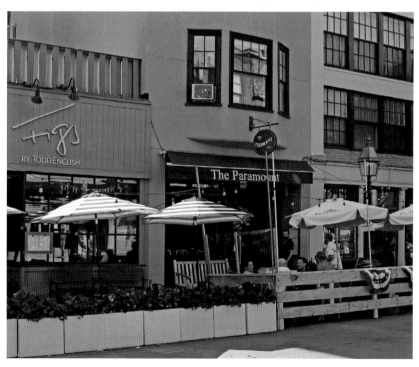

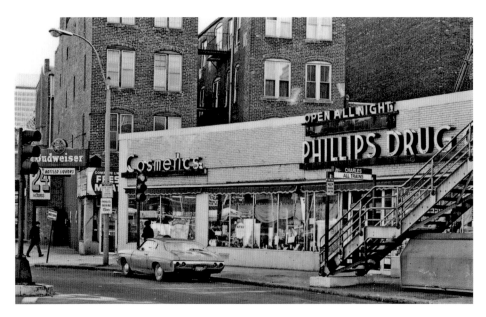

Phillips Drug Company Store was at Charles Circle, and was one of the few pharmacies in the city that remained open all night, especially as the Massachusetts General Hospital was across the street. On the right can be seen the staircase to the Charles Street Station on the Red Line of the MBTA. On the left was Glen Heller's Gulf Station, a 24-hour gas station, and the drugstore is now a CVS Pharmacy. Around the corner to the far right was the Beacon Hill Barber Shop and Fathers 3 Pub, and on the left the rear of apartment buildings on West Cedar Street.

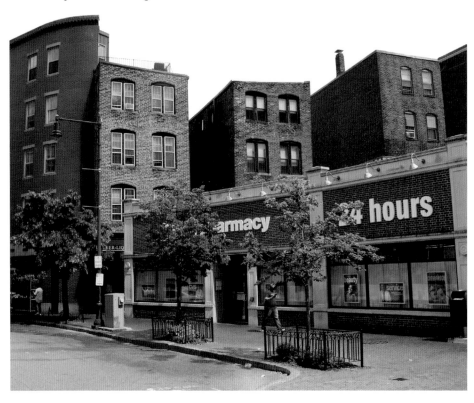